SPEED TO THE WEST
A Nostalgic Journey

Paul Atterbury and Richard Furness

www.postertoposter.co.uk

Published by
Poster to Poster Publishing
21 Bridge Street
Carmarthen
Dyfed
SA31 3JS

First Published 2016
Complete text © Paul Atterbury and Richard Furness

Published to coincide with the exhibition Speed to the West, held at the Dorset County Museum, Dorchester
between 19 March 2016 and 7 January 2017.

ISBN 9780857161468
A catalogue record for this book is available from the British Library
Layout graphic design: Poster to Poster Publishing Ltd and Obsidian Design
Image selection and preparation: Paul Atterbury/Richard Furness
Printed and bound in Slovenia on behalf of Latitude Press

ACKNOWLEDGEMENTS

We are grateful to the many people who have been generous with their time and expertise during the planning and preparation of the exhibition and this accompanying book. Without the support of Dr Jon Murden and his team, particularly Jenny Cripps and Carmel Mallinson, we would not have achieved the planning and execution in the time available. Particular thanks for the loan of items are due to friends and fellow collectors Tom Bodington, Patrick Bogue, Nick Dodson, Robbie Gardner, Steve Harvey, Barry Hayward, Jeremy Hosking, Michael Jeffery, Barry Jones, Graham Kelsey, Greg Norden, Mike Rutter, Amanda Streatfeild and Duncan Walker (the Russell-Coates Museum, Bournemouth), together with items from our own extensive collections.

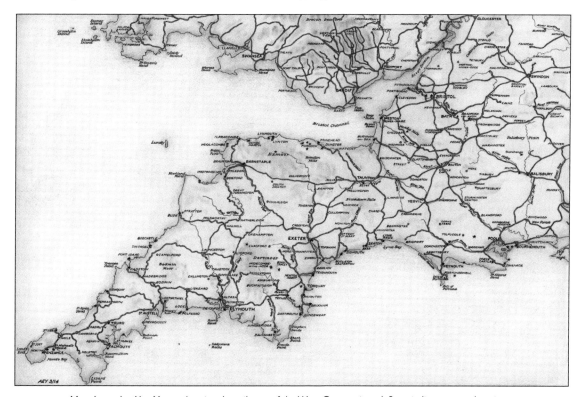

Map drawn by Alan Young showing the railways of the West Country in red. Stars indicate poster locations.

Part One of *Speed to the West* gives background information on the posters displayed in the exhibition that launched this book. The posters are arranged as if the reader was taking a journey through the West Country. We have included some 21st century items to show the artisan's craft is alive and well. Part Two covers the general history of holiday express train development as well as the detailed history of the *Atlantic Coast Express* and *Cornish Riviera Express* and other named trains that served the West Country.

FOREWORD

Railway posters bring together nostalgia for holidays and journeys past, social history, the great days of Britain's railway network and spectacular art and design in a very special way. They also highlight the importance of particular regions in Britain's cultural history and experience. Such is the West Country, a region formed by Somerset, Dorset, Devon and Cornwall, that has been famous for holidays since the Victorian era. It goes almost without saying that much of the West Country's holiday appeal was created by the railways and their ever-more sophisticated publicity machinery.

The *Speed to the West* book and exhibition have been created by Paul Atterbury and Richard Furness, and it could not have happened without their knowledge of the subject and great enthusiasm. I am delighted that they have been able to persuade the many private lenders who have contributed so much to part with treasures from their collections, and without whose generosity, faith and trust this could not have taken place.

The museum is indebted to those private and institutional collections who have supported this project, and the various funders who have helped to make this possible.

Speed to the West also marks a new chapter in the long history of exhibitions at Dorset County Museum (further information about which can be found on p. 60), both in its subject matter and as a bridge between the existing museum, and what it will become following a £13.4 million transformational development project due to start in 2017. We are especially grateful to all who have supported our museum, this book and the exhibition.

Dr Jon Murden
Director, Dorset County Museum

INTRODUCTION

In our modern world the legacies of Victorian Britain are manifold. Among the most obvious are the railway network and commercial advertising. Even in today's mass communication and digital age, there is plenty of space for the colourful poster. Through much of the 19th century, posters were largely monochrome and typographic, and reliant on the power of the printed word to convey their message. They covered walls, hoardings and public spaces, and they filled newspapers and magazines, shouting their messages in competitive ways, and advertising every conceivable commodity and activity. The technique of lithography, a process of printing directly from a flat surface (such as a smooth stone or a metal plate) prepared by the artist or designer, was developed in Germany by Senefelder at the end of the 18th century. Initially, its use was quite limited, primarily for book illustrations, and by artists for reproducing their work. In the 1840s, the process of chromolithography, or commercial multi-colour printing by lithography, was developed in Britain. It took a while for the full possibilities of this process to be understood but by the 1880s it was being used to produce large, colourful posters in which the image was more important than the words. French artists such as Toulouse-Lautrec and Chéret were the pioneers but by the end of the century the decorative poster had come to dominate the world of advertising and commerce.

Railway companies were quick to exploit the power of the poster to attract business in their fiercely competitive world. The Victorians had built a massive railway network that enabled goods and passengers to be moved all over Britain. In the process, they made accessible the more remote regions of the country and were therefore instrumental in developing tourism. Thanks to new legislation that reduced the price of rail tickets and brought in official holidays, excursions and day trips became the norm, and with that came the development of coastal and inland resorts.

Indeed, many of Britain's famous coastal resorts owe their existence to the railway; typical examples in the West Country are Ilfracombe, Newquay, Paignton, St Ives, Swanage, and Weston-Super-Mare. At the same time, hitherto inaccessible and thus unappreciated areas of landscape, such as the Quantocks, Dartmoor, the Dorset coast and West Cornwall were made accessible and popular. All this was underlined by the railway poster, a vibrant part of the railway scene from the end of the 19th century onwards.

Railway stations became colourful places, decorated with a constantly changing display of posters enticing a fast-growing customer base to travel by train to all parts of the country. The trains themselves were also part of this marketing campaign. There were many named trains serving the West Country. The most famous, the Southern Railway's *Atlantic Coast Express* from Waterloo, and the Great Western's *Cornish Riviera Express* from Paddington, epitomised the romance and efficiency of modern holiday travel. They, along with other famous trains such as the *Pines Express* and the *Bournemouth Belle*, also inspired memorable poster images.

This book, launched with an exhibition at the Dorset County Museum, brings together for the first time a magnificent display of some of the best 20th century posters designed to promote travel to the West Country. These have been chosen to represent the two golden ages of the railway poster, the classic period of the 1920s and 1930s, and the equally exciting post-war era of the 1950s and 1960s, when the newly nationalised British Railways maintained the great railway poster tradition by producing glorious images to encourage rail travel. It is today's elder generations who fondly remember seeing such 1950s images as children. This was a time when Britain was throwing off the shackles of post-war austerity and enjoying a new age of social change, economic stability and artistic creativity.

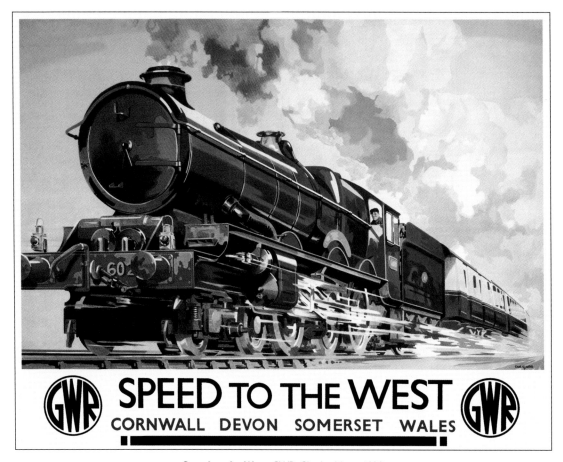

Speed to the West: GWR, Charles Mayo, 1939

PART ONE: THE WEST COUNTRY POSTERS

The posters represent a cross-section of the many hundreds produced for the West Country during the 20th century, many by some of the leading artists of the time.

The 'Speed to the West' poster is one of the most familiar ever produced. Note that Wales was included as part of the West Country. It shows a *King* Class locomotive, No. 6028 *King George VI*. Two other versions were issued by the GWR, one for the USA market which was titled *Cornish Riviera Express*, and a 1946 one with an altered tender logo and the base black line omitted. The GWR produced 3,000 copies, including 500 for the USA.

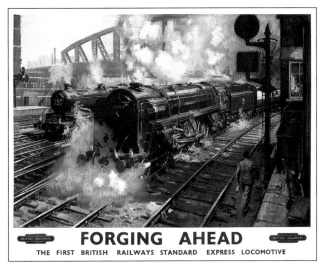

Forging Ahead: BR (W), Terence Cuneo OBE, 1951

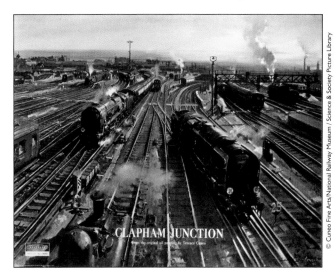

Clapham Junction: BR (S), Terence Cuneo OBE, 1962

To begin the journey here is a trio of London posters, two above by Terence Cuneo depict trains leaving Paddington, and passing through Clapham Junction from Waterloo, and a superb London view by one of the greatest poster artists, Norman Wilkinson.

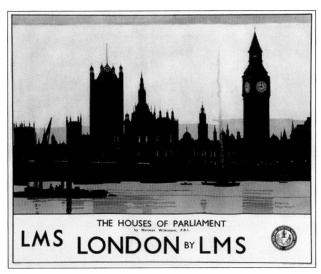

Houses of Parliament: LMS, Norman Wilkinson, 1925

'Forging Ahead' shows a new Britannia locomotive departing on a West Country express. These engines first appeared in 1951 and were marketed as the answer to Britain's aging steam locomotive fleet. Behind is a *King* Class engine, most likely *6023 King Edward II*, which had been painted in BR experimental blue livery. This engine would also be hauling a West Country-bound express.

Cuneo was often given unusual locations to produce his pictures, hence the perspective seen in the poster above. The number of trains included is not an exaggeration. Clapham Junction is Europe's busiest station with 2,000 per day currently passing through. During rush hours six or seven trains pass through simultaneously.

The *Cornish Riviera Express*, which first ran in 1904, used to leave Paddington at 10.30 a.m. (arriving in Penzance at 17.10 p.m.). The *Atlantic Coast Express*, affectionately named the *ACE*, ran out of Waterloo between 1926 and 1964. It left Waterloo just after 11 a.m., with a first stop at Salisbury, but the train contained coaches for several destinations, including Padstow, Bude, Ilfracombe and Bideford. In some years coaches were also detached for Lyme Regis, Seaton, Sidmouth and Exmouth.

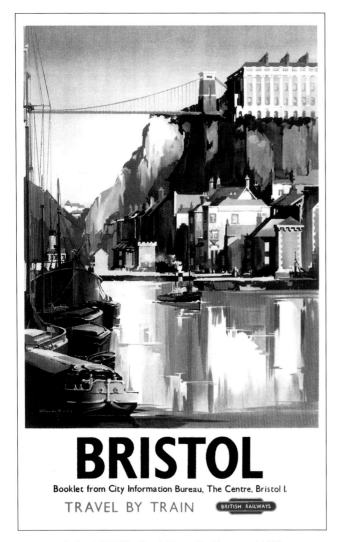

Bristol: BR (W), Claude Henry Buckle, around 1950

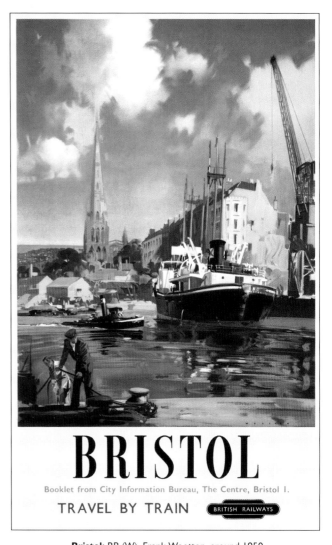

Bristol: BR (W), Frank Wootton, around 1950

The main line out of Paddington runs to Reading, where it splits. The northern arm runs via Didcot and Swindon into Bristol while the southern arm, the route of the *Cornish Riviera Express* runs via Westbury and Taunton down to Exeter, Plymouth and Penzance.

These two BR posters for Bristol from around 1950 show Brunel's Clifton Suspension Bridge across the Avon Gorge and the docks with the towering spire of St Mary Redcliffe in the background.

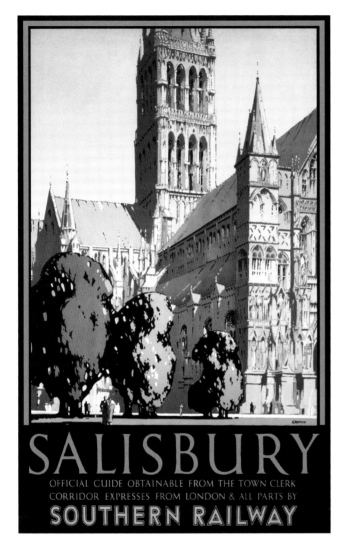

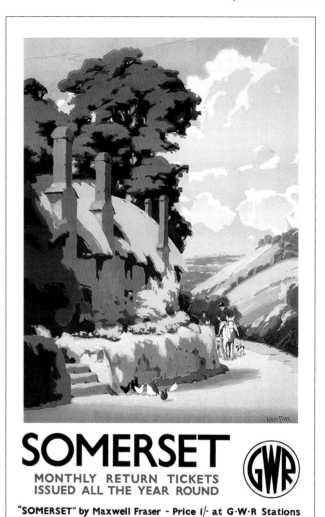

Salisbury: SR, Frederick Griffin, 1932

Somerset: GWR, Herbert Alker Tripp, 1930

Salisbury, which has one of the most beautiful of England's cathedrals, was the first stop of the *Atlantic Coast Express*. Frederick Griffin's poster focuses on the stonework rather than the lofty spire. In poster terms, Salisbury was rather overlooked, with few being commissioned.

In direct contrast is Somerset, which saw many posters issued. Alker Tripp's quintessential view of rural England is centred on the Quantock Hills and advertises one of the many guide books issued by the GWR each year.

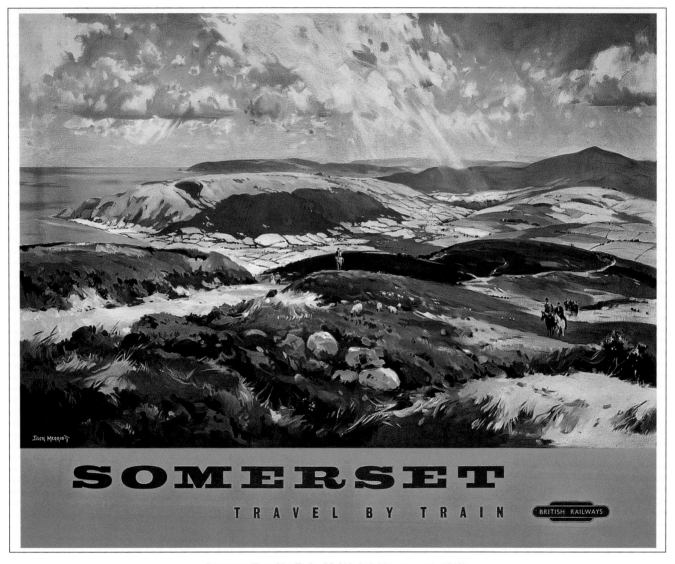

Somerset Travel by Train: BR (W), Jack Merriott, early 1960's

The late 1950s and early 1960s produced some spectacular artistic views of Britain. 'Somerset Travel by Train' is typical of panoramas that adorned many of our stations. The viewpoint is above Porlock, West Somerset, with Bossington Head to the left-hand side. Merriott's colour palette is masterly, purple heather foreground and blue skies dotted with broken clouds above: an ideal day for walking!

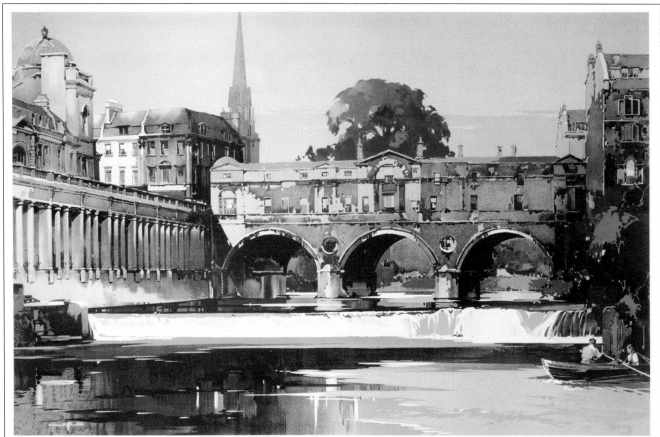

Bath – The Georgian City: BR (W), Claude Buckle, 1950

The architecturally rich city of Bath was always popular with tourists who could travel quickly and directly by train into Bath's two stations. The warm Bath limestone is shown to perfection in Claude Buckle's view of the city from Pulteney Bridge and the River Avon. Over a 35-year period Buckle painted many cityscapes that were used in railway publicity and this also happens to be the best of the Bath posters.

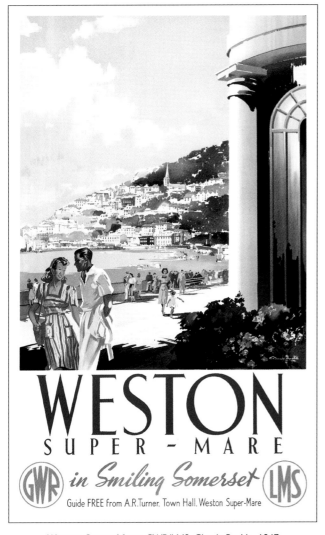

Weston-Super-Mare: GWR/LMS, Claude Buckle, 1947

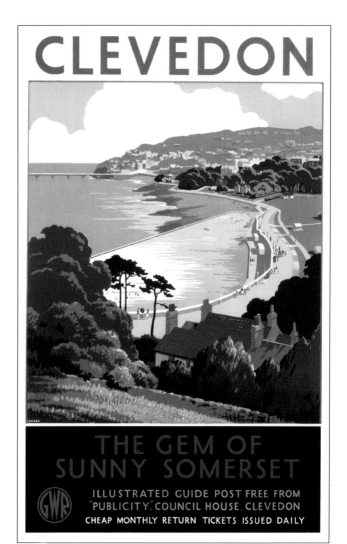

Clevedon: GWR, Leonard Cusden, 1939

One of the last GWR/LMS posters depicts the Winter Gardens Pavilion with the promenade and the town beyond. This was a popular destination for day-trippers and holiday makers from the West Midlands. Note the visitors are all smartly dressed!

Just down the coast from Weston-Super-Mare is the more genteel resort of Clevedon, shown here in one of the last posters issued before the start of World War II. Leonard Cusden produced no fewer than twenty-one posters for the GWR between 1928 and 1939.

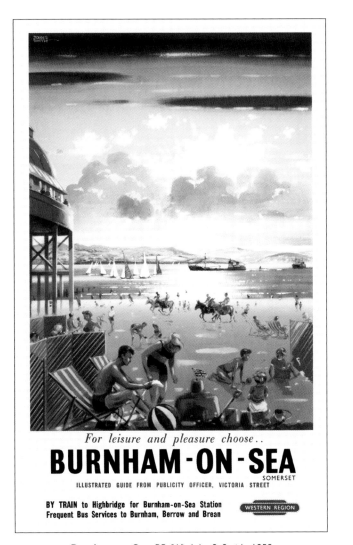

Burnham-on-Sea: BR (W), John S. Smith, 1959

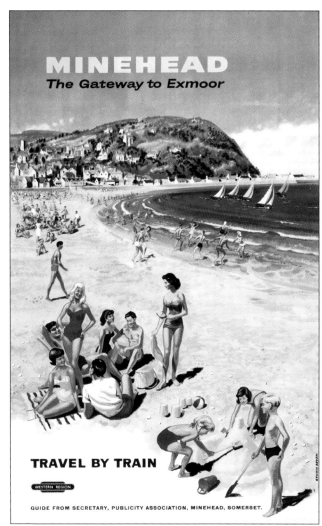

Minehead: BR (W), Studio Seven, 1962

Further down the coast is Burnham-on-Sea, a very popular 1950s family destination, as John Smith's poster shows. At the end of the 18th century it was a quiet fishing village but the arrival of the railway in 1858 changed everything. The station closed to passengers in 1951 and in 1962 for special excursions.

Built in 1874, the station at Minehead is still open today as the northern terminus of the West Somerset Railway's heritage line. Eight Minehead posters were produced, all advertising the town as the Gateway to Exmoor. This was the last poster that BR produced before they closed the line in 1971.

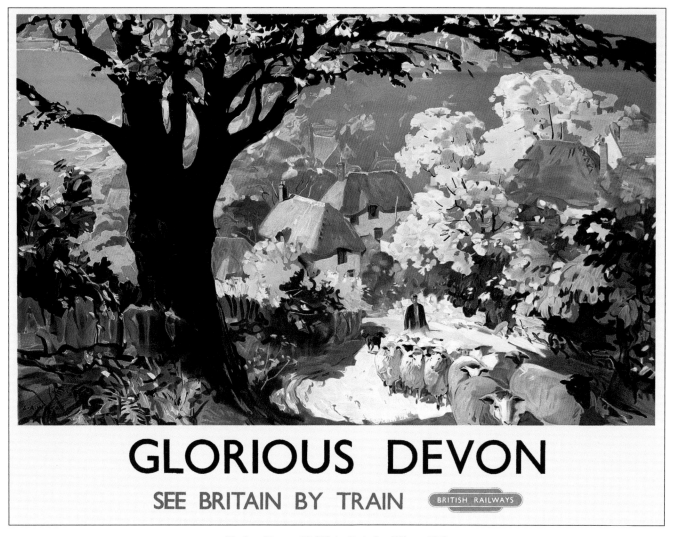

Glorious Devon: BR (W), Leslie Arthur Wilcox, 1950

After World War II Britain's bankrupt railways were nationalised and at first the newly formed British Railways had little money for advertising. This changed in the late 1940s and the next few years saw the production of many glorious pastoral and landscape views such as this one of a shepherd driving his flock along a Devon lane. Over 150 Devon posters were issued, featuring images by a range of artists. Around 1970, photographic images started to appear and posters began to lose their appeal.

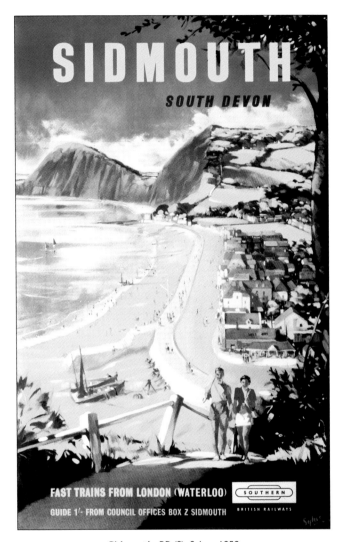

Sidmouth: BR (S), Sykes, 1959

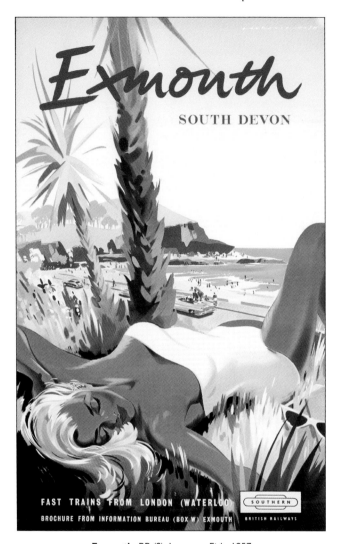

Exmouth: BR (S), Laurence Fish, 1957

The South Devon coastline has always been popular with visitors. From Seaton in the east to Plymouth in the west, there are many character seaside towns to visit. Sidmouth has changed little in the past half century. Red sandstone cliffs frame many Georgian and Regency villas and hotels.

Just west of Sidmouth is Exmouth. In this classic holiday poster, a seductive bathing belle entices us to visit a place more reminiscent of the South of France. Laurence Fish produced around twenty posters for BR's Southern Region of seaside towns all along the south coast from Kent to Cornwall.

Exeter, a city with a long and turbulent history going back to the Roman era, has two main stations. St David's, set outside the city centre, was designed by Isambard Kingdom Brunel and opened in 1844 by the Bristol & Exeter Railway. Shared by a number of other railways, it later came under the control of the GWR. It was extensively rebuilt and enlarged, in 1864 and 1913.

In 1860 the GWR's great rival, the London & South Western Railway, completed Exeter's second station, close to the city centre. Initially named Queen Street, it was renamed Exeter Central in 1930. In 1862, the L&SWR built a connecting line to St David's, to enable it to extend its network into Devon and North Cornwall. Soon, both railways were operating fast services to and from London but, owing to their different routes, their trains set off from St David's in opposite directions, an eccentricity that still survives today.

As a result of this, the routes of the two rival West Country luxury trains, the GWR's *Cornish Riviera Express* and the SR's *Atlantic Coast Express*, came together at Exeter St David's, before diverging again to service their different networks. This rivalry continued until the early 1960s and then, in 1963, British Railways Western Region took control of all lines west of Salisbury, the beginning of the end for the old L&SWR's Devon and Cornwall network.

Exeter posters tended to promote the city as a centre for visits to Devon. This one illustrates the city's dramatic history. It depicts the entry into Exeter in 1643 of Prince Maurice's Royalist army during the English Civil War.

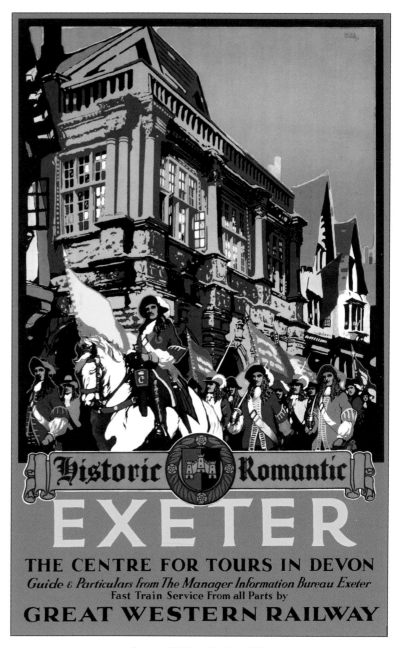

Exeter: GWR, Leslie Carr, 1931

12

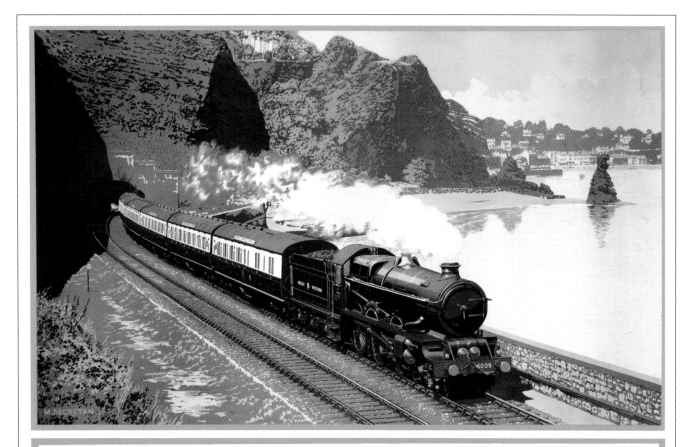

100 YEARS OF PROGRESS
1835 — 1935

100 Years of Progress 1835—1935: GWR, Murray Secretan, 1935

This justly famous poster, which is also featured on the cover of this book, was commissioned by the GWR to celebrate the railway's centenary in 1935. It depicts the down *Cornish Riviera Express*, headed by *King* Class locomotive No.6009 King Charles II, running alongside the Exe Estuary near Dawlish. This poster by Murray Secretan is a collectors' dream today.

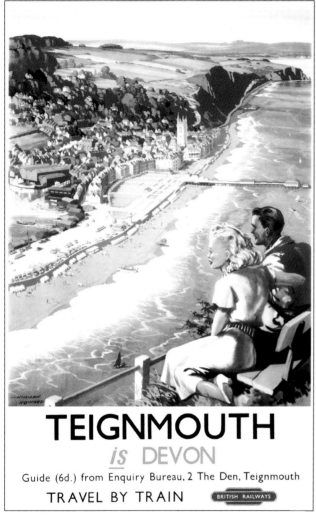

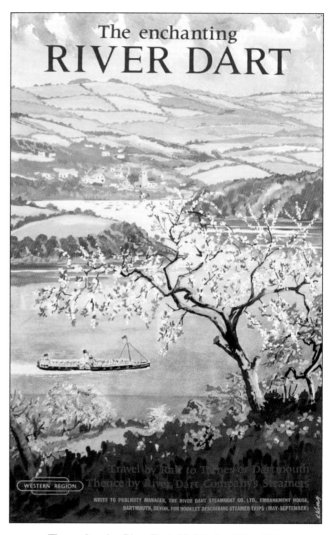

Teignmouth is Devon: BR (W), Norman Howard, 1949

The enchanting River Dart: BR (W), Cecil King, 1961

The line south from Exeter along the Exe Estuary is famously spectacular. Teignmouth, on the estuary of the River Teign, is reached a few minutes after passing Dawlish. Norman Howard's view of the town and its beach from the Ness contains plenty of artistic licence, as the viewpoint is actually to the north of the estuary.

The River Dart is, as the poster says, enchanting. Kingswear and Dartmouth face each other across the river, connected by ferries. The station is on the Kingswear side but Dartmouth also had a station, though without a railway, to sell tickets for trains and ferries. The ferry in the poster has left Dartmouth, and is bound for Totnes.

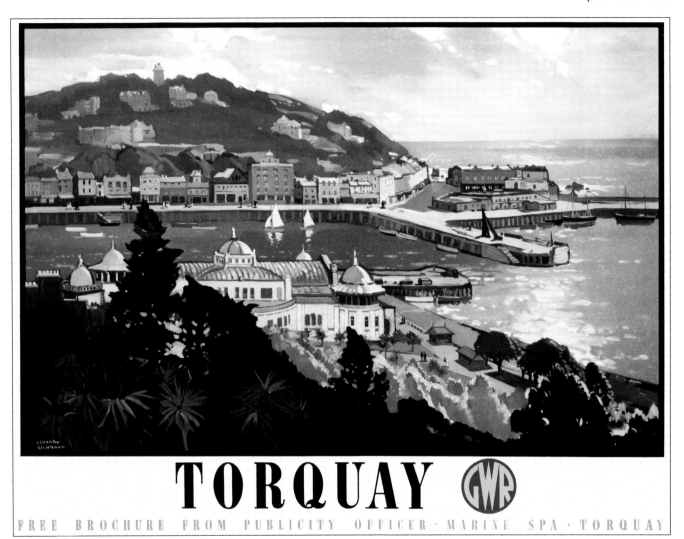

Torquay: GWR, Leonard Richmond, 1947

Torquay was a popular resort even before the railway arrived in 1859, having become fashionable during the Napoleonic wars – an alternative to going abroad! It expanded rapidly from the 1860s and the Pavilion, shown in the foreground, was completed in 1912. Somerset-born Leonard Richmond was a noted painter who worked extensively in Canada as well as in the West Country, and his work was used by both British railway companies and the Canadian Pacific Railway.

15

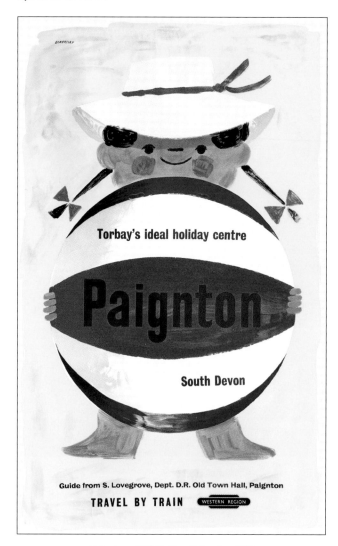

Paignton: BR (W), Tom Eckersley, 1955

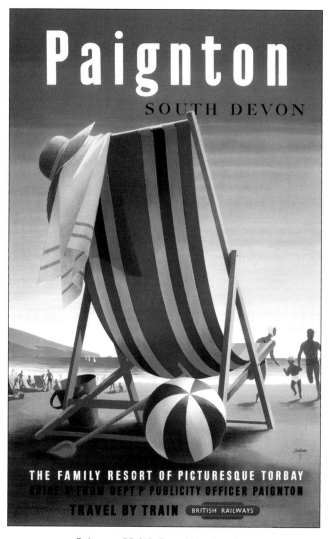

Paignton: BR (W), Reginald Lander, 1954

Just south of Torquay is Paignton, a resort developed by the railway. Before the line was built in 1859, Paignton was a quiet fishing village with a new harbour only 10 years old. It has some fine Victorian buildings, but it was the beaches that were the impetus for developing tourism.

It was well-promoted by posters. These two, by avant-garde artists, show a new style emerging in the 1950s that reflected more modern influences such as Surrealism and abstraction, rather than traditional landscape views.

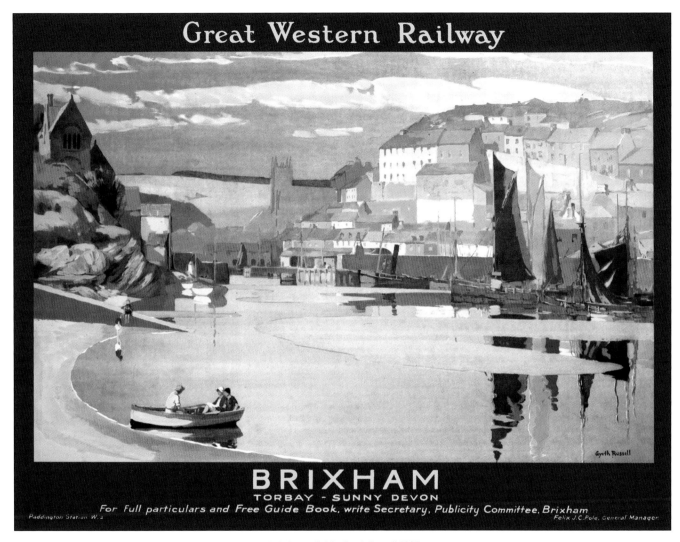

Brixham: GWR, Gyrth Russell, 1927

This is one of the most curious posters the GWR issued. Its purple border is the only example of this style ever used, but it does complement the colours Gyrth Russell used to portray this lovely South Devon fishing village. GWR borders were usually black at this time, a typical example being Cornwall by Bruhl, see page 25. The branch line from Churston served the town from 1868 to 1963.

Plymouth's railway history started in 1849 with a station opened by the South Devon Railway. However, the story really begins in 1877, with the opening of a large new station built jointly by the GWR and the L&SWR. This was known as Plymouth North Road, to distinguish it from the city's other main station, Plymouth Friary, opened by the L&SWR in 1890 following the building of a route into the city independent of the GWR. Friary remained in use for passengers until 1958 and then all services were consolidated into North Road, now just called Plymouth.

The routes of the *Cornish Riviera Express* and the *Atlantic Coast Express* met again in Plymouth, though the different routes meant that the timings were also very different, the *Cornish Riviera* taking 4 hours from London and the *Atlantic Coast* over five. At Plymouth the powerful *King* Class locomotives were replaced by the lighter *Castle* Class for the meandering journey through Cornwall. In 1948 the Laira shed in Plymouth, the GWR's main regional depot, had an allocation of twelve *Kings* and thirteen *Castles*.

Thanks to its deep water harbour, Plymouth has a long maritime history, including national heroes such as Sir Francis Drake, and the centuries-old connection with the Royal Navy. Drake features on a number of posters, while another shows the departure of the Pilgrim Fathers in 1620. However, by the early 20th century Plymouth was best known as a holiday destination, and the gateway to Devon and Cornwall, and most posters celebrate this. Harry Riley's poster is a typical example, a crowded scene looking down from the Hoe towards the Lido, with the busy harbour in the background. Sailors and holiday-makers cheerfully mingle together.

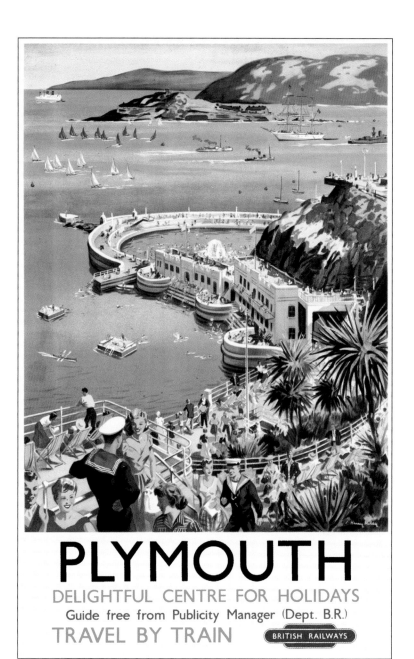

Plymouth: BR (W), Harry Riley, 1954

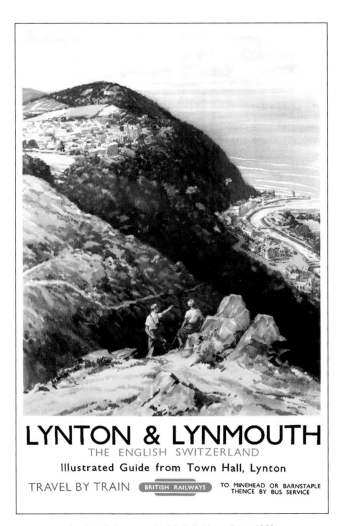

Lynton & Lynmouth: BR (W), Harry Riley, 1952

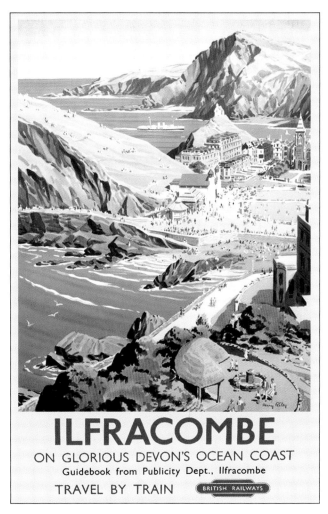

Ifracombe: BR (W), Harry Riley, 1962

Dozens of posters were issued to promote travel to North Devon, and these two by Harry Riley for British Railways are classic examples. 'Lynton & Lynmouth' shows both towns, linked by a cliff railway. Issued early in 1952, it shows Lynmouth before the devastating floods of August that year which destroyed much of the town and harbour, and left thirty-four dead.

This view of Ilfracombe was regularly used by poster artists to promote this popular and well-sheltered North Devon resort, famous for its beaches and cliffs. The town, served by both GWR and SR trains, was one of the final destinations for a section of the *Atlantic Coast Express*. Steep inclines on the route to Ilfracombe meant that many trains were double-headed.

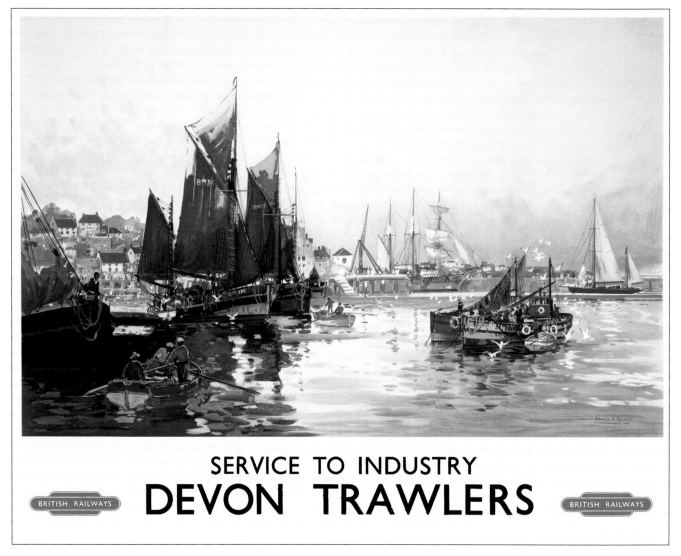

SERVICE TO INDUSTRY
DEVON TRAWLERS
BRITISH RAILWAYS BRITISH RAILWAYS

Service to Industry Devon Trawlers: BR, Frank Henry Mason, 1949

Posters in the 1930s famously depicted industrial scenes, and British Railways maintained the tradition, a reminder that the newly nationalised company needed to expand its freight traffic as well as passenger services. Frank Mason was a noted maritime painter and Official War Artist whose strongly coloured images were used by many railway companies from the 1920s onwards.

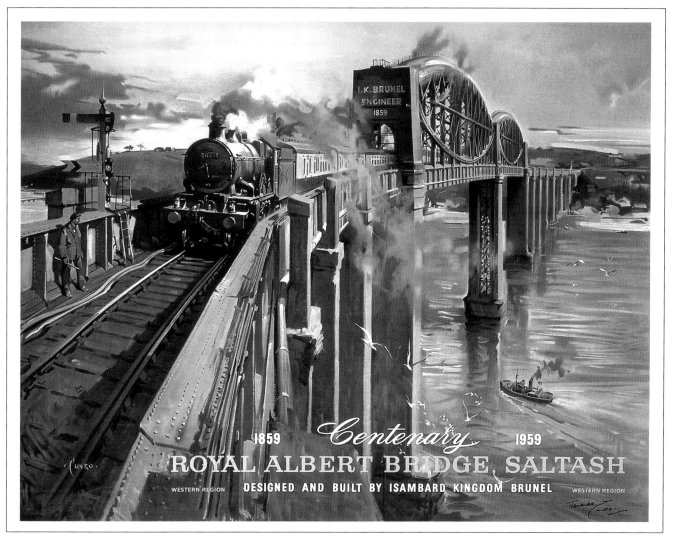

1859 Centenary 1959, Royal Albert Bridge, Saltash: BR (W) Terence Cuneo OBE, 1959

One of Terence Cuneo's best-loved posters shows a West-bound express headed by a *Castle* Class locomotive crossing the Royal Albert Bridge over the Tamar, an image synonymous with travel to the West Country. It was issued to mark the centenary of Brunel's last great masterpiece, and an extraordinary engineering achievement. Two great tubular sections, each 140 metres long, were jacked up into position 30 metres above the river, to allow the passage of ships. Still in daily use, the bridge has always marked the entry into Cornwall for holiday-makers.

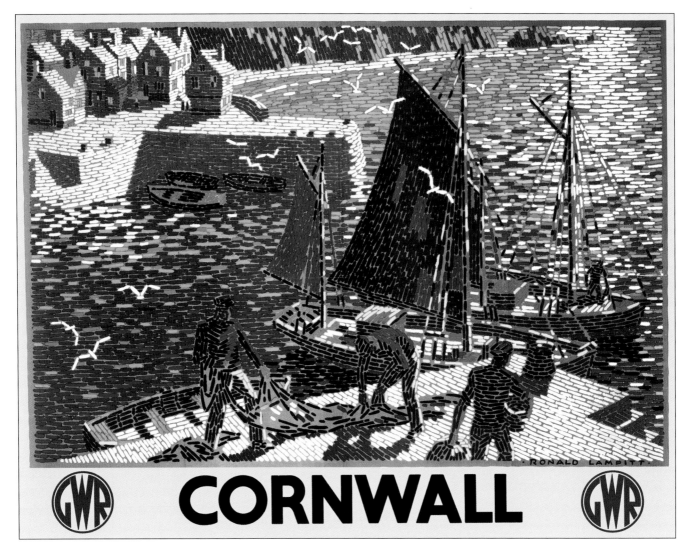

Cornwall: GWR, Ronald George Lampitt, 1935

This unusual mosaic-type poster was one of a trio commissioned in this style in 1935 (Devon at Sidmouth and the Cotswolds in Gloucestershire were the others). It contrasts markedly to the more artistic work of Frank Mason seen earlier, but is certainly very eye-catching in its use of a Pointillist, or mosaic style. Lampitt produced twenty-three posters for the LMS, GWR and SR, plus all BR regions from 1925 to 1961. The location of the poster could be Polperro, but some artistic licence has been used: a lovely poster!

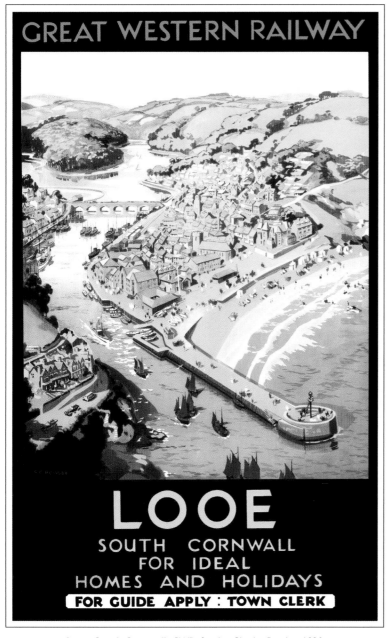

Looe, South Cornwall: GWR, Stanley Charles Rowles, 1930

With its dramatic landscape, spectacular coastline and long days of sunshine, Cornwall has long been one of Britain's most popular holiday regions. However, before it was joined to the national railway network in 1859, it was inaccessible and little-known and so it was the train that brought the county's fishing villages, towns, beaches and wild landscape into prominence.

These posters vividly portray Cornwall's many alluring features and the artists naturally make the connection between Cornwall and the French or Italian Riviera's. Picturesque Looe, depicted here by Stanley Rowles, could be in Brittany.

A traditional fishing village built on both sides of the River Looe estuary, Looe became a fashionable resort in the late Victorian period. A branch line to the town from Liskeard was opened in 1860, initially for freight but from 1879 for passengers. The station can be seen in the poster, on the right bank where the ships are moored. Today, Looe still has its railway, one of Cornwall's famous branch line survivors.

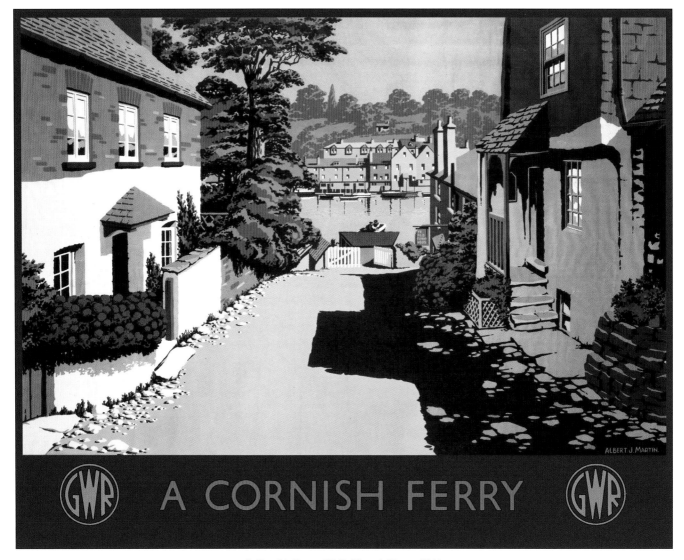

A Cornish Ferry: GWR, Albert J. Martin, 1946

South Cornwall is characterized by tidal river valleys penetrating far inland. One of the longest and largest is the Fal Estuary and here Albert Martin's poster depicts Bodinnick, looking across the river towards Fowey. The ferry, which runs between the two communities, is reputed to have started in the 13th century. Martin produced just two GWR posters, the second in 1947.

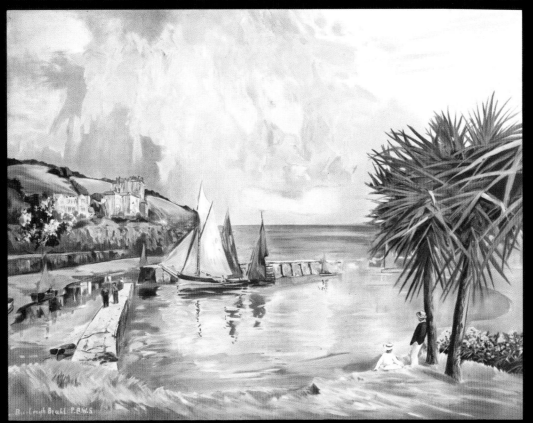

The Cornish Riviera: GWR, Louis Burleigh Bruhl, 1928

The GWR was a major publisher of guide books and related material. This poster promotes the 1928 edition of *The Cornish Riviera*, an annual production. While the phrase The English Riviera, coined by the GWR, is firmly linked to the Torquay and Paignton area of South Devon, no one really knows what the GWR meant by The Cornish Riviera. Perhaps everything from Lostwithiel to Penzance?

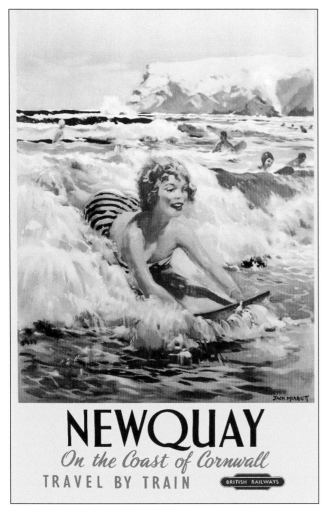

Newquay: BR, Jack Merriott, c.1955

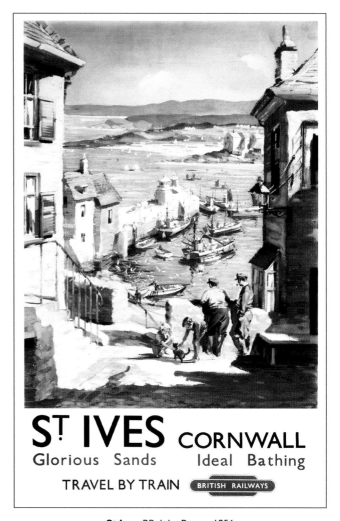

St Ives: BR, John Power, 1956

All the resorts along Cornwall's northern coast, such as Bude, Padstow and Newquay, were able to develop once the railway had arrived. Before tourism, the only sources of local income were fishing, china clay production and tin-mining. Newquay, with its big Atlantic rollers, soon became a surfing centre, the inspiration for Jack Merriott's lively poster.

St Ives is 150 miles from Bude, and that entire stretch of North Cornwall was greatly changed once the railways had made it accessible. St Ives, and Newlyn were famous artists' colonies from the late Victorian period onwards and by the 1950s fishing, beaches and painting had made St Ives internationally famous.

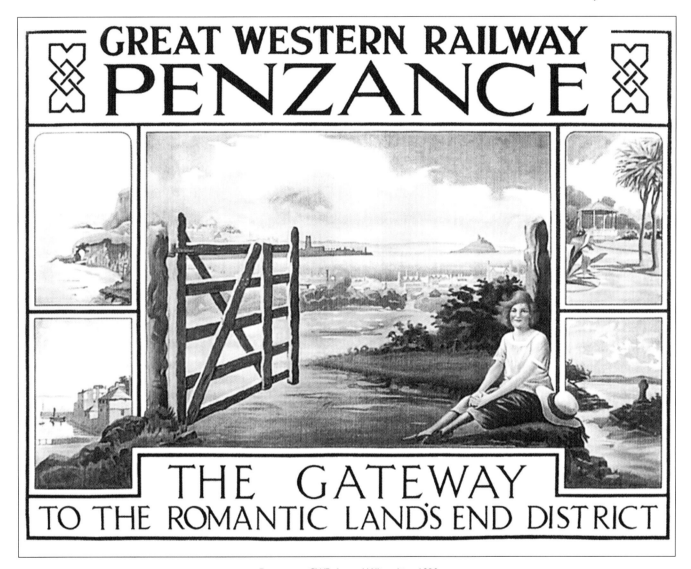

Penzance: GWR, James William Lias, 1920

This is one of the oldest and certainly the rarest of the posters in this book. The GWR had a long history in the West Country but its territory was greatly extended after the 1923 Grouping. This poster, the only one that Lias produced for the GWR, harks back to the Edwardian era, with its small montages surrounding a main image. Lias was born in Newton Abbott in 1885 and worked in Manchester before becoming Head of the Truro School of Art. He died in 1941.

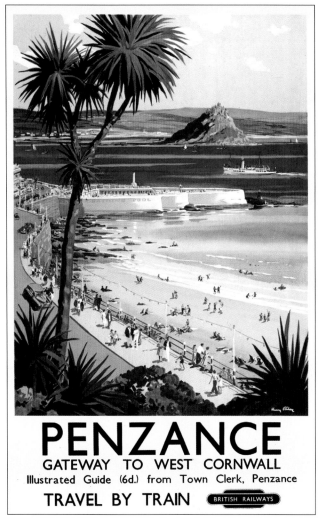

Penzance: BR (W), Harry Riley, 1952

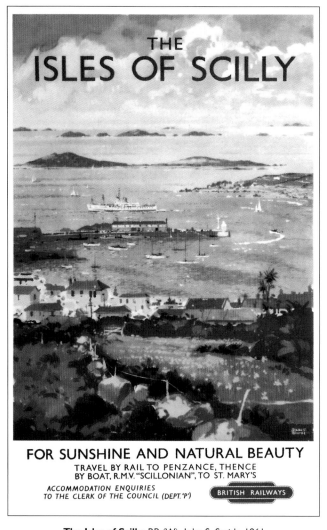

The Isles of Scilly: BR (W), John S. Smith, 1961

Although Penzance had a station from 1852, there were no through trains to Plymouth and London until 1859. It is very much the end of the line, with the town, the beach and the harbour just beyond the buffers. This classic view shows the esplanade, the lido and St Michael's Mount.

Penzance is the main access point for trips to the Isles of Scilly, and both the GWR and BR produced posters promoting Scilly's particular appeal to holiday-makers. The GWR also had a locomotive named after Tresco Abbey.

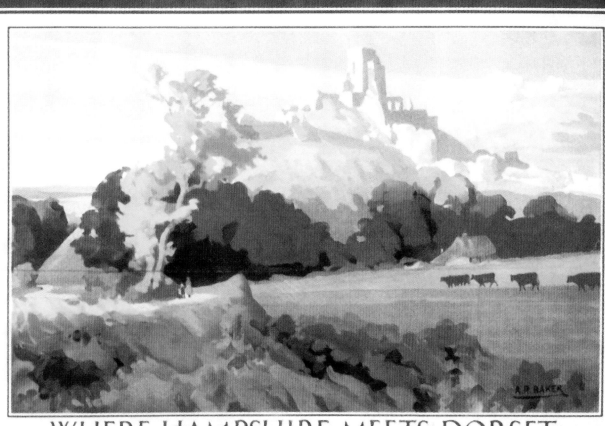

Where Hampshire Meets Dorset: SR, A. R. Baker, 1935

This rare poster issued by the SR shows the iconic view of Corfe Castle, as seen by passengers on the branch line to Swanage. Famously destroyed by Cromwell in 1645, the castle's history goes back to the 11th century. When the poster was issued, Bournemouth was in Hampshire, hence the title.

Dorset has a long history of human habitation, stretching back to Neolithic times. The ancient name of *Doseteschire* first appears in official records in 940 AD, but before that the Romans had built a settlement at Dorchester, which they called Durnovaria. The county became an English shire in the 7th century, so the correct title should be Dorsetshire, though modern usage has dropped the shire. In 1963, when the poster map was produced, Bournemouth was in Hampshire but boundary changes from 1974 brought the town and its area into Dorset and so posters from Bournemouth are included in the book.

Dorset was served by four main lines, which opened from the 1850s, mostly built in sections by small independent companies. First to arrive was the line from Bristol to Weymouth, completed in 1857 and operated by the GWR. Next came the two main routes from London, operated by the L&SWR. The line from Waterloo to Exeter, completed in 1860, has stations today at Sherborne and Gillingham. The line from Waterloo to Weymouth was completed in 1865. The final arrival was the famous Somerset & Dorset Joint Railway, whose challenging route was finally opened in 1875. In addition, a cross country route connected Poole with Salisbury via Wimborne, and there were branches serving Swanage, Portland, Abbotsbury, Bridport and West Bay, and Lyme Regis. Most of these lines are shown on the 1963 poster map. Today, the cross-country route has gone, along with all the branches, but the major loss to the county and its holiday economy was the closure in 1966 of the Somerset & Dorset line.

Today, with its World Heritage status for the Jurassic Coast, Dorset is a famous county. It has always been known for its spectacular coastline and pretty inland villages, which made the county popular with tourists from the Victorian period onwards, thanks in part to the railway network. It is, therefore, surprising that the railway companies only issued about forty Dorset posters during the 20th century, all of which feature coastal resorts. The railways really missed a promotional opportunity by ignoring the inland towns of Dorset, such as Sherborne, Shaftesbury and Wimborne Minster, along with the county's most famous resident, the

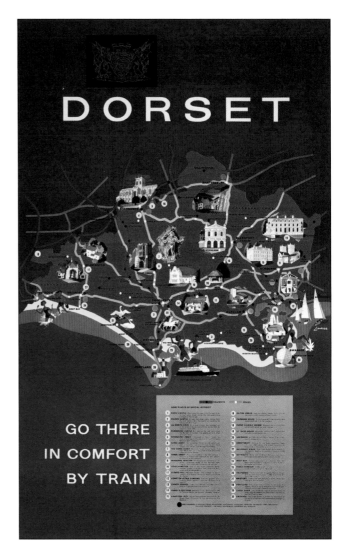

Dorset: BR, Reginald Lander, 1963

writer Thomas Hardy. There is a surviving painting for an Abbotsbury poster, which was never issued, and the SR did commission the artist Donald Maxwell to produce a carriage print of Hardy's birthplace.

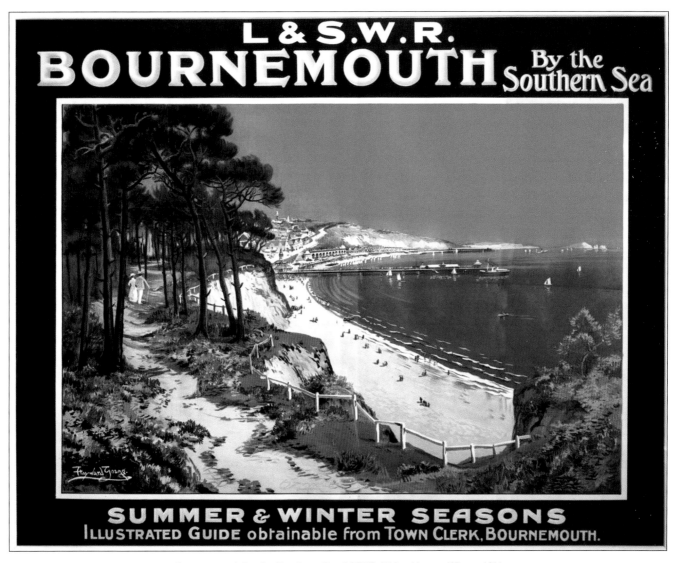

Bournemouth by the Southern Sea: L&SWR, Walter Hayward Young, 1916

This rare L&SWR poster is 100 years old this year, depicting the broad sweep of beach to the immediate west of the town. Before the coming of the railways in 1870, Bournemouth had developed into a very fashionable resort, because of the curative properties the climate seemed to offer. By 1840, a marina and swathes of pine trees had gradually transformed the heathland into a premier resort, with six miles of beaches and cliffs rising behind to afford shelter from inland breezes.

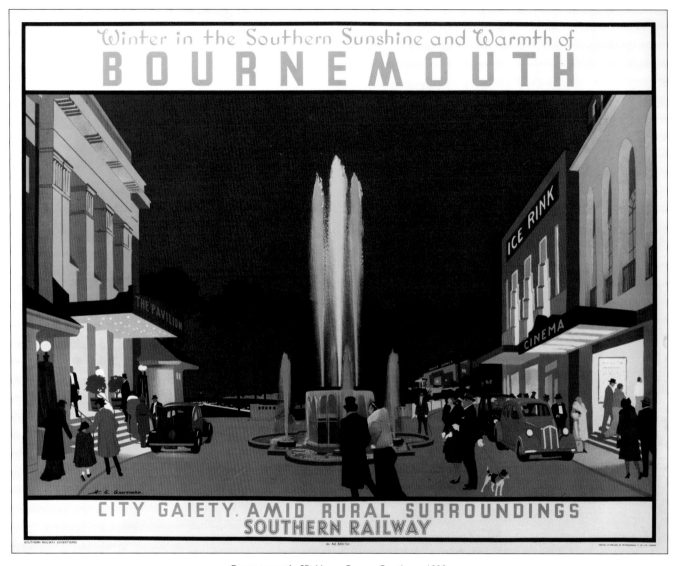

Bournemouth: SR, Henry George Gawthorn, 1939

Being such a premier resort, the railways advertised Bournemouth's delights all the year round. Gawthorn's pre-World War II poster shows an idealised view of Westover Road with the Pavilion on the left, the ice rink on the right and the Pavilion fountain moved to the centre of the image. Various people, smartly dressed, and period cars, typical of the 1939 social scene, complete an image far removed from the gathering storm clouds of war.

Bournemouth: LMS, Langhammer, 1930s

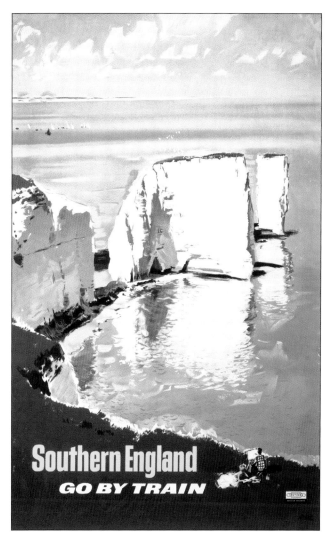

Southern England: BR (SR), Langhammer, 1960

Express trains came into Bournemouth from all directions once the railway links were complete. One of the most famous was the *Pines Express* from the Midlands and the North that travelled via the now closed Somerset & Dorset line from Bath.

The 1960 view of Old Harry Rocks near Swanage, one of Dorset's most famous sights, was one of a series used to promote travel throughout the south of England.

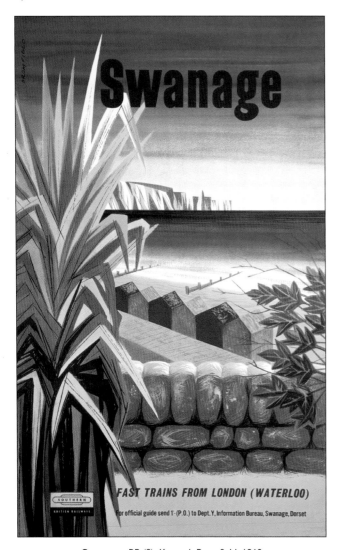

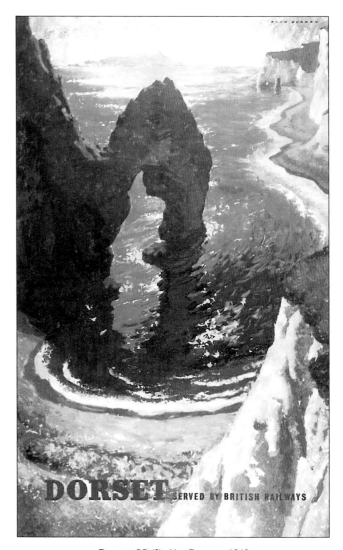

Swanage: BR (S), Kenneth Bromfield, 1960

Dorset: BR (S), Alan Durman, 1960

The Southern Region of BR spent a lot of money and effort to promote all the south coast resorts between 1955 and 1961. This pair of posters was produced for the 1960 season and shows a view from the beach at Swanage towards Old Harry Rocks and a colourful view of the unique stone arch of

Durdle Door, whose outline is enhanced by the setting sun. These show attempts by the marketing department to weld different styles together to try and present a unified message to prospective travellers.

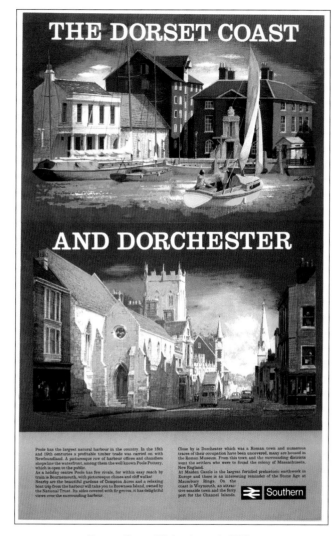

Dorset Coast: BR, Lander, early 1970s

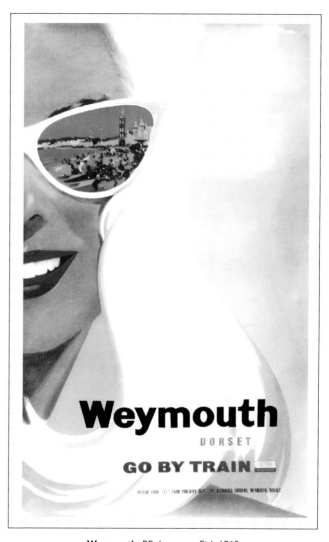

Weymouth: BR, Laurence Fish, 1960

This pair of posters shows excellent use of colour by BR as design became more inventive from the 1960s. The Lander poster, which shows modern images of Poole and Dorchester, is from a series featuring all the counties served by the Southern Region.

The 1960 Diana Dors look-alike by Laurence Fish, one of the most creative of the modern poster designers, captures the essence of summer, with the seafront reflected in the girl's sunglasses.

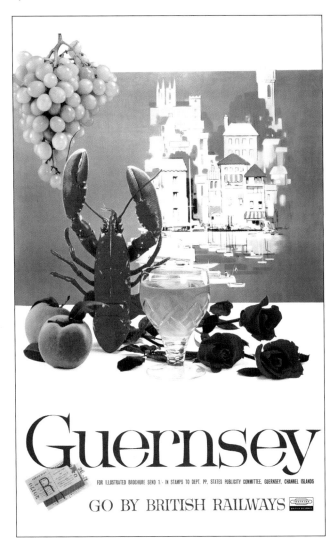

Guernsey: BR (S), Laurence Fish, 1960

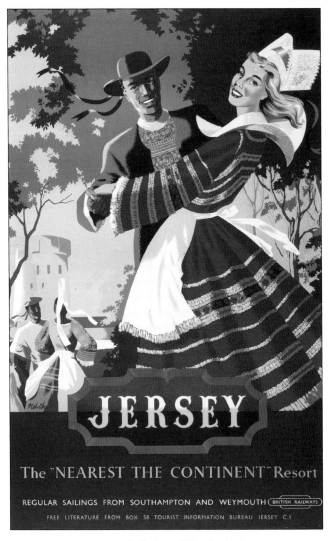

Jersey: BR (S), Reginald Lander, 1959

Weymouth was the main embarkation point for BR steamers to the Channel Islands, with boat trains operated by both GWR and SR. Both posters show the bright colours and abstract style of modern design. Guernsey, with its clever

blend of photography and artwork, was voted Poster of the Year in 1960, in a competition covering all areas of poster design. Lander's Jersey poster shows a couple taking part in the Battle of the Flowers and has a definite continental feel.

Ferry services from Weymouth to the Channel Islands had commenced in 1794 with a packet steamer that initially transported goods. Eventually passengers were taken and many Dorset families moved to the Islands. The opening of the Weymouth Harbour tramway in 1865 allowed the GWR and L&SWR to share access to the harbour quayside. The L&SWR had little need, so by 1889 the GWR took over operations and upgraded the line to allow passenger trains to run right alongside the steamers. The first direct ferry train ran on 4th August 1889. They remained in control until BR was formed in 1948 and services ran continuously until September 1987. The named express *The Channel Islands Boat Train* left Paddington around 9 a.m. and arrived at Weymouth Quay at 12.20 p.m. for the 1 p.m. departure to the Islands. The return train left the quayside at 3.45 p.m. arriving in Paddington at 8.35 p.m. Poole is now the point of departure for passengers and cars to Jersey and Guernsey.

Rather surprisingly, no railway posters were issued for Abbotsbury, Bridport, Chesil Beach, or the quite magnificent coast from Burton Bradstock to Charmouth. The SR however in 1926 produced a view from Charmouth westwards towards the Exe Estuary. Two posters were issued for Lyme Regis of which the one alongside is rare and collectable. Trains ran on the tortuous branchline from Axminster to a small station that opened in 1903 but had been closed by 1965. It was located high above the town and three quarters of a mile from the centre. Lyme Regis is surrounded by steep hills which meant a more central station was not feasible. Lambert's poster shows the famous breakwater, The Cobb, which has featured in novels and films.

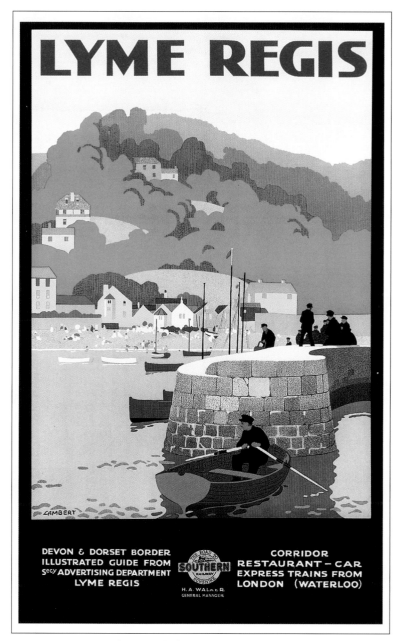

Lyme Regis: SR, Alfred Lambert, 1926

THE 21ST CENTURY POSTER

In the past, the poster was the internet of the period, when there were no computers and digital imagery had not been commercially perfected. Artistic posters faded after 1970, but recently there has been a marked return to artistic images for commercial advertising. The use of computer generated pictures has brought freshness and vividness to modern posters and the pair here, commissioned to celebrate the 2014 Weston-Super-Mare poster extravaganza, shows the Grand Pier and Winter Gardens in their full colourful glory. Created by Manchester-based artist Stephen Millership, they demonstrate the use of technology in classic advertising.

The Winter Gardens were built in 1927 in the Art Deco style and were opened by Earnest Palmer, Deputy Chairman of the GWR. Set in extensive gardens with tennis and putting green facilities, it soon became popular and the oval-shaped ballroom became the place for decades of social events. The Grand Pier is a Weston landmark, but with a chequered history. The original pier opened in 1904. It was damaged by fire in 1930 but in 2008 the whole of the original pavilion was destroyed in a second blaze. The poster shows the new £39 million pier which took two years to complete. At 400 metres, it is a cornerstone of Weston's 21st century tourist attractions.

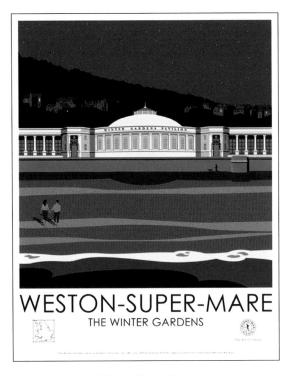

Weston-Super-Mare
The Grand Pier: Stephen Millership, 2014

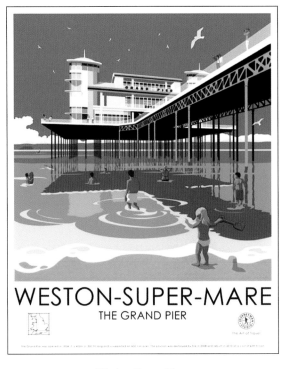

Weston-Super-Mare
The Winter Gardens: Stephen Millership, 2014

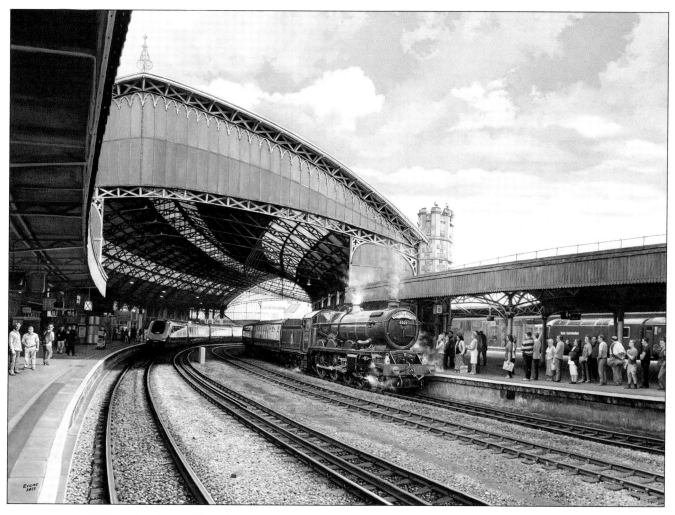

A Vision of the Future. The *Torbay Express* at Temple Meads, headed by *King* Class No. 6023, Edward 11, Bryan Evans

This painting has been included because it spectacularly depicts the romance of steam travel to the west. The locomotive Edward 11 was rescued from the scrapyard and over a 30-year period of restoration has been returned to its former glory. In recent years, the *Torbay Express* has been revived, running on summer weekends from Temple Meads to Kingswear (for Dartmouth). This painting is a hoped-for future scene, with Didcot's flagship engine at the head of a summer express. It is a vivid reminder of the excitement that occurred at stations up and down the nation as packed trains prepared to leave for the coast. Portishead-based Bryan Evans has cleverly juxtaposed the motive power of the past with present day expresses, all in Brunel's wonderful trainshed.

The poster opposite is very recent but uses a tried and tested banner message. With the economic closure of so many lines around our nation, a new tourist industry has sprung up, the heritage railway lines. Many have produced their own contemporary posters but this is one of the first where a major train operating company First Great Western, recently rebranded Great Western Railway, has partnered with a preserved line to offer through ticketing from all over Britain onto the heritage tracks.

The Bodmin & Wenford Railway has an interchange connection with the national network at Bodmin Parkway. The GWR had opened a branchline from Bodmin Road to Bodmin General in 1887. A year later a connection was made to the Bodmin North to Wadebridge line. All these had closed by 1983 but in the following year the Bodmin Preservation Society had been formed and from 1987, they have grown to become a major tourist attraction for this part of Cornwall.

This new poster cleverly uses one of the preserved engines alongside an HST 125 as they both 'Speed to the West'. It shows that the enduring power of the artistic railway poster is very much alive.

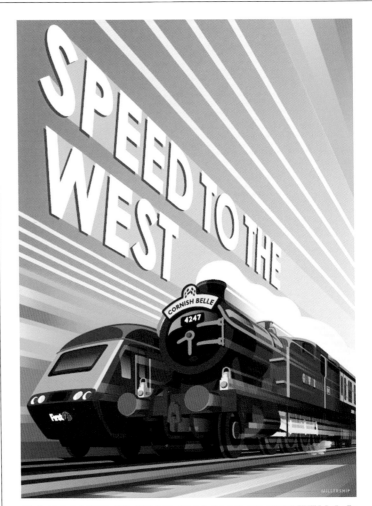

Speed to the West: Stephen Millership, 2015

PART TWO: SPEED TO THE WEST

Historians, enthusiasts and collectors now look back on the first six decades of the 20th century as a kind of golden age of the railway poster, thanks to their extraordinary ability to weave stories and transport everyone to beaches, luxury hotels, glorious landscapes, historic centres and other romantic places. Today, these posters have a universal appeal to young and old alike, who are enticed by the beauty and artistic quality of their images, reflecting as they do the historic development of modern Britain.

Of all the journeys people made during the 20th century, those setting off from the towns and cities to the coast by train are the most fondly remembered. On every summer Saturday, stations were thronged with people and probably the most vividly recalled are those to Cornwall, Devon, Dorset and Somerset, the glorious West Country. This was an area served initially by a number of smaller train operating companies, but in 1923 economics forced a grouping into four big companies, the GWR, the SR, the LMS and the LNER. The GWR and the SR were the prime operators for travel in the West Country.

From this point on railway publicity machines became more effective and posters more memorable. Towns used to compete to employ the best poster artists of the day, as they sought to gain financial advantage over their neighbours by having their beaches, hotels and streets full of tourists. This resulted in many posters being commissioned.

In the 'See your own Country First' poster the GWR has compared the outline of Cornwall to that of Italy, with the south coast being similar to the Italian Riviera around Capri.

They used the French Riviera in a similar manner with the promenade at Torquay directly compared to the promenade at Nice.

Direct links from London to the whole of the West Country encouraged *Speed to the West*, a marketing slogan coined and successfully employed by the GWR. The SR's *Atlantic Coast Express* from Waterloo and the GWR's *Cornish Riviera Express* from Paddington epitomised holiday rail travel and spawned several iconic images. Other slogans included *Glorious Devon* and *Smiling Somerset*.

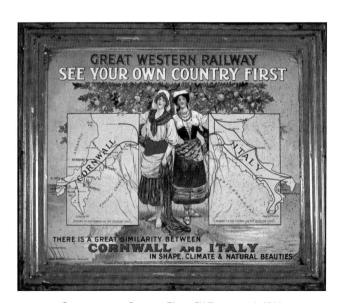

See your own Country First: GWR, unsigned, 1941

The London-Penzance service at first ran via Bristol from July 1904, but became the evocative *Cornish Riviera Limited* when it was finally launched as the new all-year round train in the summer of 1906, using the shorter line via Westbury. The service was designed for the holiday and tourist market. Once into Cornwall the train would stop at Truro, Gwinear Road and St Erth as these stations were junctions for important branch lines serving the burgeoning holiday destinations around Falmouth, the Lizard and St Ives. In the late Victorian and early Edwardian years the GWR gained the reputation for speedy services, thanks to the flat and level tracks designed originally by Brunel for high speed running, and this was to be developed over the following thirty years.

Cornwall became as attractive in winter as the summer months as the company created a steady stream of marketing pamphlets and publications, initially under the guidance of publicity officer Felix Pole, who was later to become GWR's General Manager. The idea of *Winter in the West* was further developed by author and journalist S. P. B. Mais in various pamphlets, which eventually grew into best-selling books.

At the beginning of the 20th century the GWR was the most adept at promoting both itself and the region it served, having strong links with those seaside towns and villages it had been instrumental in developing. The GWR's own hotels, the Manor House near Moretonhampstead and the Tregenna Castle in St Ives set the standard for style and elegance.

On top of all this the marketing team cleverly forged an overall holiday brand, underpinned by their annual publication *Holiday Haunts* and eye-catching supporting posters that adorned Paddington, Birmingham, Bristol and other large city stations.

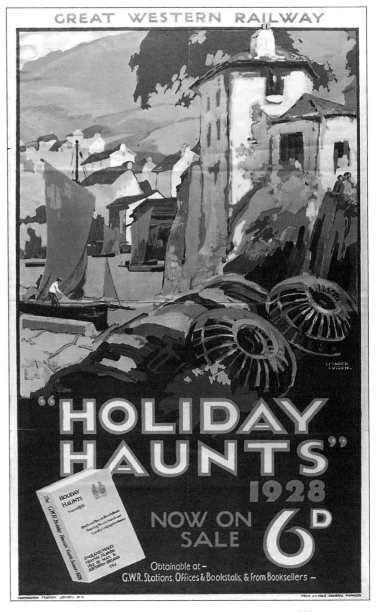

Holiday Haunts: artwork for the annual publication, 1928

When it came to speed it was the development and presentation of their *Castle* Class and later *King* Class engines that proved decisive. Stories about the *Cheltenham Flyer* really made the GWR's reputation for speed. For many years, *The Cheltenham Flyer* was known as the fastest train in the world. Introduced in 1923 from Paddington to Cheltenham, the 77.3 mile journey was booked at 75 minutes. Fortunately, the schedule was not too difficult for a *Saint* or later a *Castle* locomotive, making the service the fastest in Britain. 1929 saw five more minutes taken off the time and by 1931 this had come down to 67 minutes, giving an average speed of 77.8 mph. Finally, in 1932 *Castle* No. 5006, *Tregenna Castle* did the whole journey in 57 minutes giving the new average as 81.7mph. Needless to say the GWR marketing machine went into overdrive. By the time Charles Mayo designed his iconic poster in 1939, named expresses and speed became inexorably intertwined. When the GWR wanted a fresh, dynamic image for the American market they swiftly turned to Mayo's poster but rebranded it as the *Cornish Riviera Express* and naturally the GWR of England!

In addition to their famous posters, the railways also presented information and other advertising in eye-catching ways. Carriages were fitted with series of prints of well-known places commissioned from leading artists and route maps stimulated further travel. Illustrated here are carriage

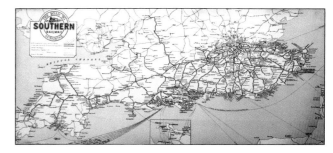

Carriage Route Map, SR, 1939

route maps issued by the SR and the GWR. These reveal that the SR's trains, and notably their *Atlantic Coast Express* had a much less direct, and thus much slower route, once they had passed Exeter.

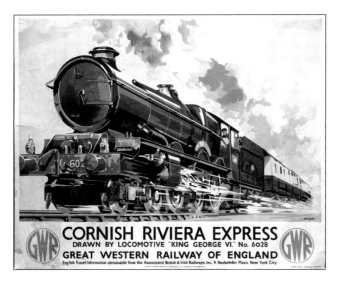

Cornish Riviera Express: GWR, Charles Mayo, originally 1939

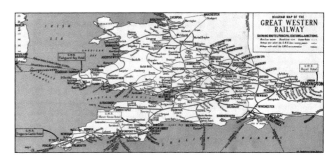

Carriage Route Map, GWR, late 1930s

NAMED TRAINS SERVING THE WEST COUNTRY

From the 1920s and 1930s named trains proliferated all over Britain, and this habit continued well into the BR era, and even beyond – see box below. The West Country was no exception, with over twenty named trains being recorded apart from the *Cornish Riviera Express* and the *Atlantic Coast Express*.

Named trains were always popular, particularly during the summer months, and were eagerly awaited en route by trainspotters. Among the best known were the All-Pullman *Devon Belle* and the *Bournemouth Belle*.

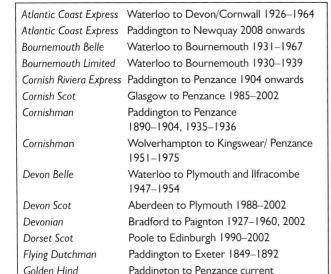

Atlantic Coast Express	Waterloo to Devon/Cornwall 1926–1964
Atlantic Coast Express	Paddington to Newquay 2008 onwards
Bournemouth Belle	Waterloo to Bournemouth 1931–1967
Bournemouth Limited	Waterloo to Bournemouth 1930–1939
Cornish Riviera Express	Paddington to Penzance 1904 onwards
Cornish Scot	Glasgow to Penzance 1985–2002
Cornishman	Paddington to Penzance 1890–1904, 1935–1936
Cornishman	Wolverhampton to Kingswear/ Penzance 1951–1975
Devon Belle	Waterloo to Plymouth and Ilfracombe 1947–1954
Devon Scot	Aberdeen to Plymouth 1988–2002
Devonian	Bradford to Paignton 1927–1960, 2002
Dorset Scot	Poole to Edinburgh 1990–2002
Flying Dutchman	Paddington to Exeter 1849–1892
Golden Hind	Paddington to Penzance current
Mayflower	Kingswear and Plymouth to Paddington 1957 onwards
Merchant Venturer	Paddington to Weston-Super-Mare 1951 onwards
Merchant Venturer	Paddington to Penzance via Bristol current
Night Riviera	Paddington to Penzance late 19th century to present
Pines Express	Liverpool, Manchester and Sheffield to Bournemouth 1927–1967
Royal Duchy	Paddington to Kingswear and Penzance 1957 onwards
Royal Wessex	Waterloo to Bournemouth, Swanage and Weymouth 1951–1967
Torbay Express	Paddington to Paignton 1923 onwards
Wessex Scot	Poole to Glasgow 1984–2002

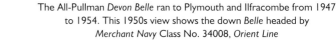

The All-Pullman *Devon Belle* ran to Plymouth and Ilfracombe from 1947 to 1954. This 1950s view shows the down *Belle* headed by *Merchant Navy* Class No. 34008, *Orient Line*

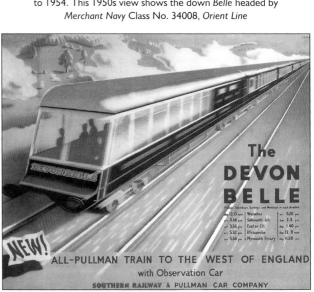

The Devon Belle: BR (S), Marc Severin, 1947

The *Devon Belle* was an All-Pullman service from Waterloo to Ilfracombe and Plymouth. The Ilfracombe passengers enjoyed the benefit of a magnificent observation car, shown in Marc Severin's SR poster produced to coincide with the start of the new service. Two carriages of this type were built for this express and both have happily survived in the south-west, one on the Swanage Railway (car number 14) and one on the Dartmouth Steam Railway (car number 13). The train ran non-stop from Waterloo to Sidmouth Junction (160 miles), and then called at Exeter, Barnstaple and finally Ilfracombe. Carriages were detached at Exeter for Plymouth. The rare Severin poster occasionally comes up for auction and is always keenly contested.

The other important destination for named expresses was Bournemouth and two were in service, the *Bournemouth Limited*, which only ran for a short period before World War II and the *Bournemouth Belle* between 1931 and 1967. When the SR introduced its *Schools* Class engines in 1930, they were immediately put to work on the *Bournemouth Limited*. The timing of this non-stop service was 8.30 a.m. up to London and 4.30 p.m. return, offering a reasonable time in London for those living in the Bournemouth area. The 'Shep' poster, produced in 1938 to mark the introduction of new carriages for the service, shows the *Limited* headed by *Schools* Class No. 392, Blundells.

BR revived the service in 1951, to mark the Festival of Britain, but renamed it the *Royal Wessex* and extended it to serve Bournemouth, Wareham for Swanage and Weymouth. Always popular with holiday-makers, this famously long and heavy train continued in operation until 1967.

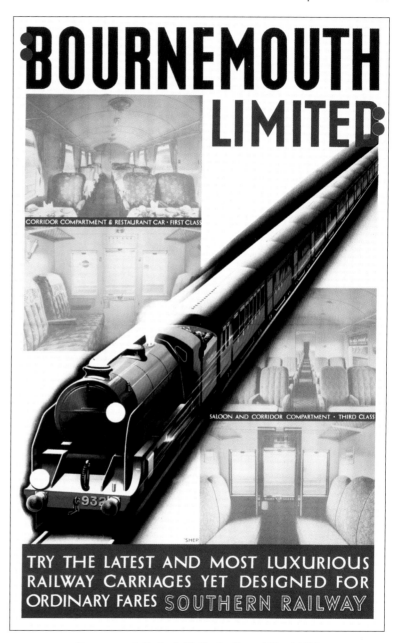

Bournemouth Limited: SR, Charles Shepard 'Shep', 1938

ATLANTIC COAST EXPRESS

This section looks at the history and the route of the *Atlantic Coast Express* and includes additional posters relevant to the journey. The *ACE* ran between 1926 and 1964. At its peak it included coaches for nine separate destinations. In 2008 it was reintroduced by First Great Western (now GWR), running on summer Saturdays between Paddington station, London, and Newquay.

In 1923, the GWR was heavily advertising holidays in the West Country and the newly formed SR decided they must compete. John Elliot, public relations assistant to the Southern Railway, proposed to the board in December 1924 that the next batch of express passenger locomotives be named after characters from Arthurian legend (the *King Arthur* Class), and that a named train be introduced. The name was chosen as the result of a competition run in the staff magazine and the winning entry was submitted by Mr. F. Rowland, a guard from Woking who won a prize of three guineas for suggesting *Atlantic Coast Express*.

From the beginning the *ACE* effectively had five destinations, three in Devon and two in Cornwall. Even many years later, as Harley Bishop's 1960 poster shows, these main destinations remained at the centre of the marketing. Plymouth, by far the largest city in Devon, was served via Okehampton and Tavistock. The steep gradients and tortuous nature of the route beyond Exeter meant that it was not possible to run a fast timetable.

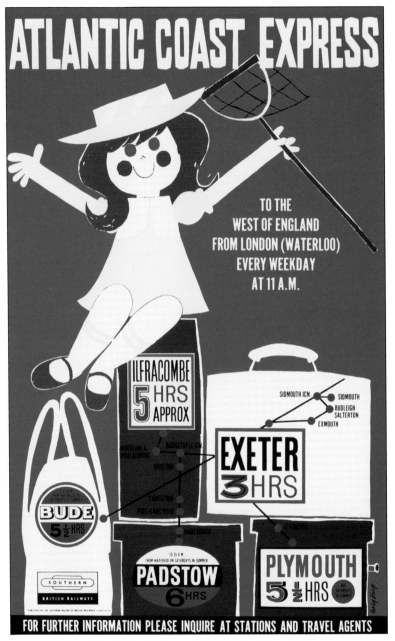

Atlantic Coast Express: BR (S), Harley Bishop, 1960

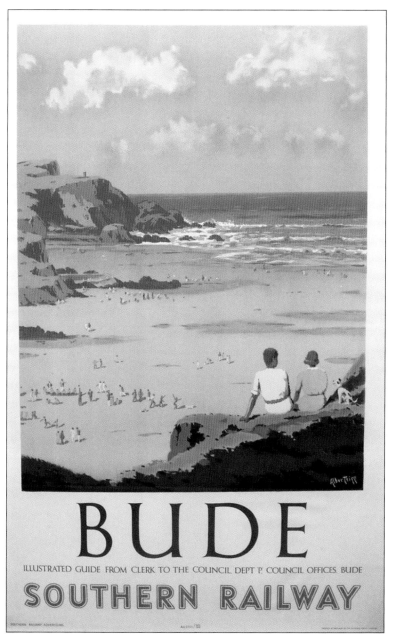

Bude: BR (S), Herbert Alker Tripp, 1947

Halwill Junction was the junction for the two Cornish destinations: Bude, a small but growing resort on the most northerly part of the Cornish coast, and Padstow, a fishing port at the mouth of the River Camel and the Southern Railway's most distant outpost, almost 260 miles from Waterloo. At the junction, the Bude carriages were detached and the Padstow section turned south to Launceston, skirting the edge of Bodmin Moor before reaching Camelford. A swift descent to Wadebridge followed, through countryside described by Poet Laureate John Betjeman. The route followed the estuary of the River Camel on its final approach to Padstow, a scenic journey shown in Eric Hubbard's 1947 poster (see next page), one of the last produced by the Southern Railway. Today, this is one of England's most popular cycle tracks.

Bude has been popular since Victorian times, although in earlier years its harbour gave it local importance. Its railway posters were issued mainly in the inter-war years when the SR saw it as an alternative to the south coast resorts. The station opened in 1898 but by 1966 this had closed, leaving Bude further from a railway link than virtually any other English town.

Padstow was a major fishing port, but the fleet has been diminished by the silting of the estuary and the harbour approach. It has, however, grown as a yachting centre and has a fine marina. It is also widely appreciated for the excellence of its seafood and world-class restaurants exist in the town. Padstow station was the most westerly on the Southern network but it closed in 1967.

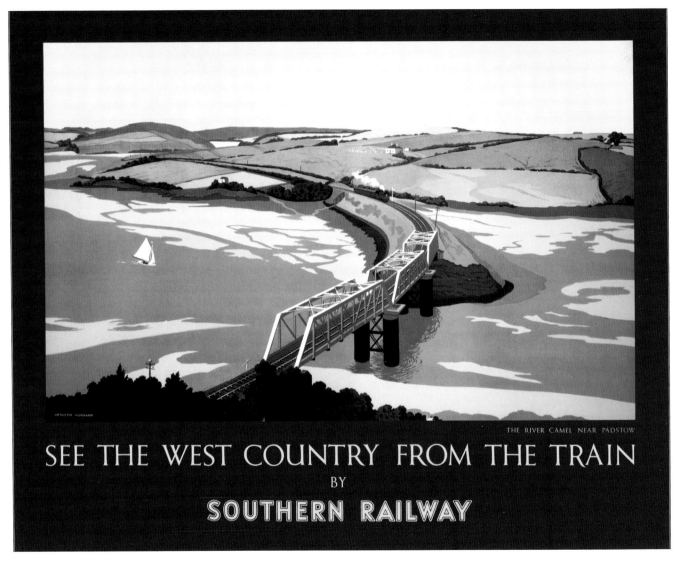

THE RIVER CAMEL NEAR PADSTOW

SEE THE WEST COUNTRY FROM THE TRAIN
BY
SOUTHERN RAILWAY

See the West Country from the Train: BR (S), Eric Hesketh Hubbard, 1947

The North Devon portions of the *ACE* followed the route from Exeter Central through Crediton to Yeoford before turning north-west and reaching the valley of the River Taw at Lapford. Thereafter the line hugged the river to Barnstaple Junction, the junction for the two North Devon destinations of the *ACE*. From here the Torrington portion followed the estuary of the Taw westward to Instow before turning south along the River Torridge to Bideford and its destination of Great Torrington.

The portion for Ilfracombe, another port that owes its status as a holiday destination to the coming of the railways, continued northwards. Started from Barnstaple Junction, the branch for Ilfracombe headed north through Barnstaple Town and on to Braunton before climbing steeply to Mortehoe and then descending more steeply to the terminus at Ilfracombe.

Adjacent is the only poster so far recorded for Barnstaple. This was an early L&SWR issue in 1904 and shows even then corridor expresses with luncheon and dining cars were being run from Waterloo. The two posters on the next page, one for Bideford and one for Woolacombe & Mortehoe together show the endearing quality of days out in North Devon. The wide beaches at Woolacombe & Mortehoe and Saunton Sands were for decades some of the most favoured beaches in the UK and easily reached by train in the great days of BR.

At various times other destinations had through coaches from the *ACE*. These were Exmouth, Sidmouth, Seaton and Lyme Regis.

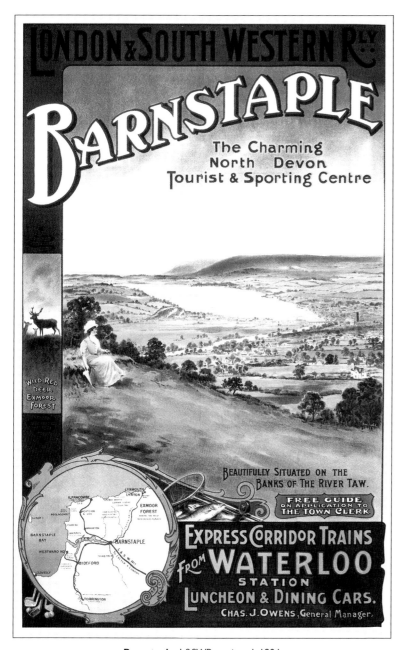

Barnstaple: L&SWR, unsigned, 1904

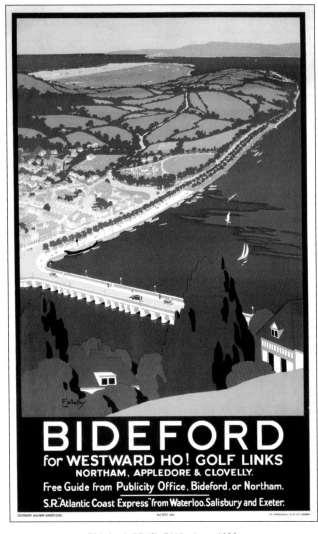

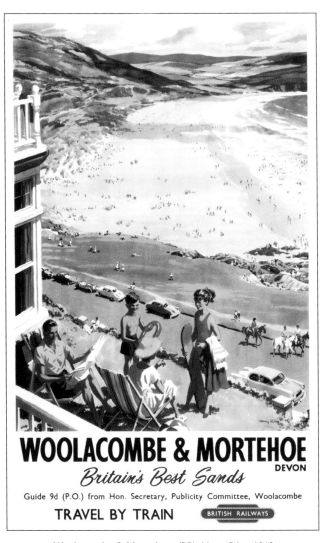

Bideford: BR (S), F. Whatley, c.1920s

Woolacombe & Mortehoe: (BR), Harry Riley, 1960

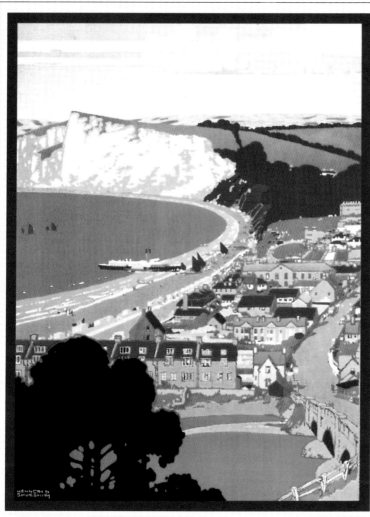

SEATON, DEVON

GUIDES AND ALL INFORMATION FROM THE SECRETARY
OF THE SEATON DISTRICT CHAMBER OF TRADE, OR
THE CLERK, SEATON URBAN DISTRICT COUNCIL, SEATON, DEVON.

CORRIDOR EXPRESSES & CHEAP FARES BY

SOUTHERN RAILWAY

Seaton: BR (S), Kenneth Shoesmith, 1930

The heavy reliance on holiday passengers meant that the volume of traffic was very seasonal. On summer Saturdays, the *ACE* consisted of up to five trains departing from Waterloo in the 40 minutes before 11.00 a.m., stretching resources on the long single-track branch lines to the limit. In the winter timetable, one train was sufficient for all of the branches, and stops were made at all but the most insignificant stations west of Exeter. Significant delays for these trains were frequent at the junctions where coaches were detached or attached and shunted between the various sections of the train: express it was not!

In later years, a carriage was detached at Salisbury to join a following stopping train along the main line, and two carriages were detached at Sidmouth Junction, one for Sidmouth and one for Exmouth via Budleigh Salterton. The restaurant and buffet cars were normally removed during the major division at Exeter Central. It can be seen therefore that the *ACE* was a complex service to run to keep abreast of market demand.

The 1950s marked the highpoint of the *ACE*, with the first mile-a-minute timing on the Southern Region with a 12.23 p.m. arrival in Salisbury, 83 miles from Waterloo. Gradual improvements in schedules continued until the final acceleration in autumn of 1961, when the journey time from Waterloo to Exeter Central came down to 2 hours 56 minutes. From June 1963 the Bude, Torrington and Plymouth through carriages were withdrawn except on summer Saturdays. The remaining services survived through the following summer until, on 5 September 1964, *West Country* Class No. 34023 *Blackmoor Vale* hauled the last up *ACE* out of Padstow.

One of the famous headboards carried by locomotives hauling the *Atlantic Coast Express*

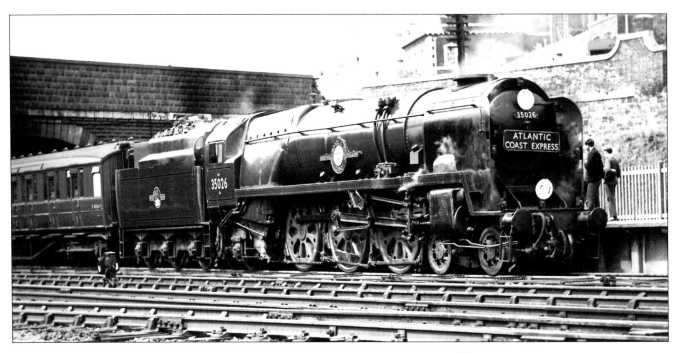

The *Atlantic Coast Express* in the early 1960s, hauled by *Merchant Navy* Class No. 35026 *Lamport & Holt Line*,
about to depart from Exeter Central on its complex journey westwards

CORNISH RIVIERA EXPRESS

The *Cornish Riviera Express* (CRE), was the epitome of speed and luxury, a train loved by passengers from its early development between 1904 and 1906. Soon Saturday's became a magical time at Paddington station as passengers prepared for their journey west. Gleaming carriages with destination headboards helped passengers to join the correct part of the train. Suitable reading material, preferably published by the GWR, was essential but it was the romance of Cornwall that stirred the passengers' imagination. The *CRE* was *the* way to travel to Cornwall.

The *CRE* was so popular with travellers that it ran in two portions on summer Saturdays until World War I when it was suspended. The train resumed in 1919 and there was a gradual acceleration in passenger services with the West of England Paddington to Penzance train restored to a 10.30 a.m. schedule. By the early 1920s the *Cornish Riviera Limited*, as the *CRE* was first known, was firmly established as one of the country's leading luxury train services.

A famous headboard carried by locomotives hauling the
Cornish Riviera Express

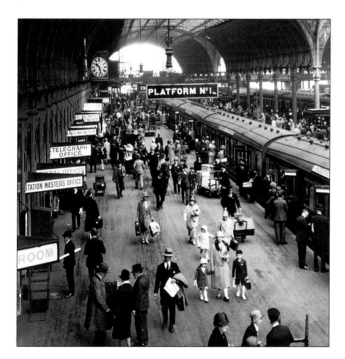

It is nearly 10.30 a.m. and the *Cornish Riviera Express* is about to depart from Paddington's No.1 platform in the summer of 1927

In 1923 new 70ft long carriage were introduced so the GWR was able to carry even more passengers hauled by a new gleaming *Castle*. Between 1923 and 1950, 171 of these locomotives were produced and they proved popular with crews and passengers alike. They were designed by Charles Collett based on the earlier *Star* engines and built at the GWR giant Swindon works. The GWR was the leading exponent of the art of the slip coach which allowed carriages to be dropped without stopping at intermediate points for other destinations en route to the west. Typically during this period, a thirteen- or fourteen-coach formation would have three two-coach sections at the rear of the train to slip the carriages for Weymouth and the Channel Islands, Ilfracombe and Minehead and Torquay.

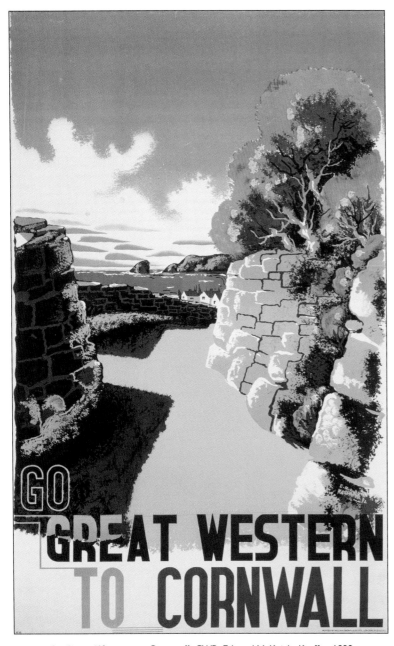

Go Great Western to Cornwall: GWR, Edward McKnight Kauffer, 1933

In the years before World War II, the *CRE* (and the *Cornishman* a sister train that ran directly after the *CRE*) was incredibly popular. By the 1939 summer season the *CRE* had grown to eight separate portions: the main part of the train with restaurant car for Penzance and one through coach for destinations to St Ives, Falmouth, Newquay and Kingsbridge. More easterly destinations such as Ilfracombe and Minehead were serviced by the Taunton slip and two Weymouth and Channel Islands carriages were slipped at Westbury. A number of West Country coastal resorts in Cornwall, Devon and Dorset were dependent on both the GWR and Southern Railway. In the mid- to late-1930s there was co-operation (and friendly rivalry) between the two companies. They even issued joint posters of some West Country destinations, such as Plymouth.

The marketing slogan *Go Great Western* seemed to be everywhere and in keeping with the modern dynamic image they had developed, the GWR commissioned the leading artist of the day, American Edward McKnight Kauffer to produce a series of six posters for Devon and Cornwall. The poster opposite was revolutionary for that time, based on the reputation McKnight Kauffer had built with his many London Transport posters. The building of their brand was cleverly engineered by the Paddington marketing department. Today, all McKnight Kauffer artworks are all immensely collectable.

Equally revolutionary for his time was Claude Henry Buckle, and in the GWR series *This England of Ours*, this quiet Londoner produced some classics. The famous poster on the next page for Totnes is just one example.

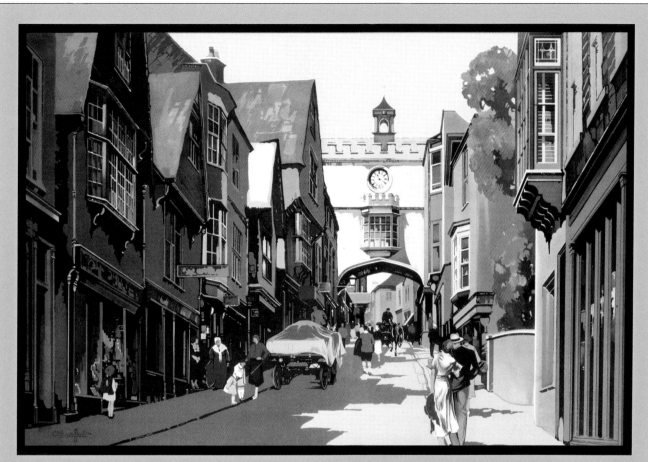

'THIS ENGLAND OF OURS'
Historic TOTNES - Devon

Historic Totnes: GWR, Claude Henry Buckle, 1933

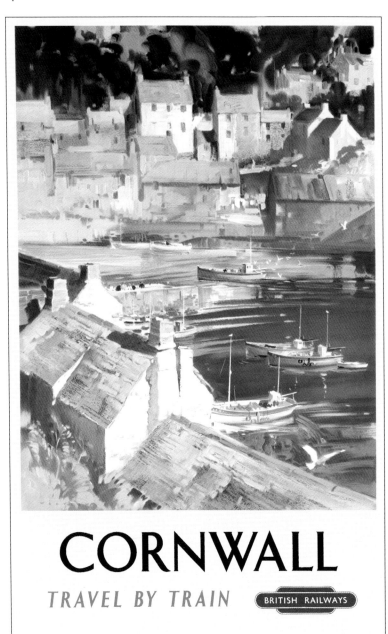

Cornwall: BR (W), Frank Wootton, 1954

After World War II, there was a gradual return to normality and the pre-war timings. The *CRE* continued to be extremely busy with increasing numbers of paid holiday travellers *Going Great Western*. In addition, although the numbers of private cars and coach companies were increasing, the vast majority of roads remained inadequate for the demand, a situation exploited by BR's marketing department. It was a long way by road to the west of Cornwall, so the *CRE* remained popular, aided by BR (W)'s promotional efforts. In the BR years, some superb poster views of the West Country were seen all over Britain. Frank Wootton's 1954 view of Polperro is typical of the second *Golden Era* of railway poster art.

The end of steam on the *CRE* was marked by a rebranding exercise in April 1958, though the journey time seemed to steadily increase even with the introduction of new diesel power. *Cornish Riviera Express* headboards were attached to sparkling Brunswick green-liveried *Warship* Class diesel hydraulic locomotives, thus creating a new modern era that reconnected to GWR's heritage as the train was now made up of new Mk1 carriages painted in chocolate and cream. The headboard-carrying days on the *CRE* service ended around 1962 as the newer *Western* Class 52 diesels began life on Western Region, displacing the *Warships* that had proven to be less reliable than the *Kings*. The *Westerns* could keep to the 4-hour timetable to Plymouth, even with a 500-tonne load and a stop at Taunton. Soon Plymouth was reached in 3 hours 35 minutes and this service was maintained in 1977 by the Class 50 diesels. The HST 125 trainsets first appeared in 1981 and are still in use today.

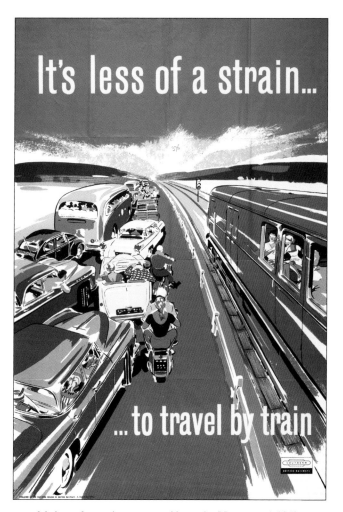

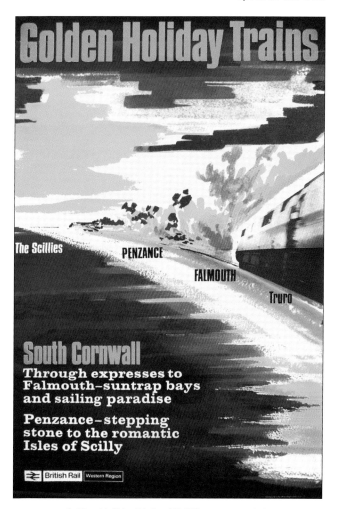

It's less of a strain... to travel by train: BR, unsigned, 1960s

Golden Holiday Trains: BR (W), unsigned, 1970s

In August 1957 a smart *Castle* Class locomotive No.5028 *Llantilio Castle* hauls a Liverpool-bound express along the sea front at Dawlish
(Photo: R.W. Hinton)

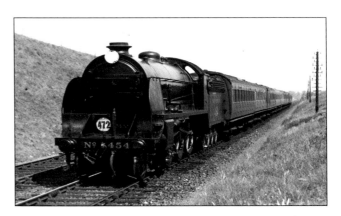

After leaving Exeter, *King Arthur* Class locomotive No. 454 *Queen Guinivere* heads a section of the *ACE* westwards in May 1935

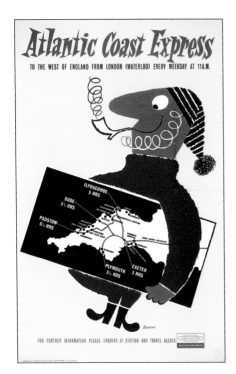

Atlantic Coast Express: BR (S), Stevens, 1950s

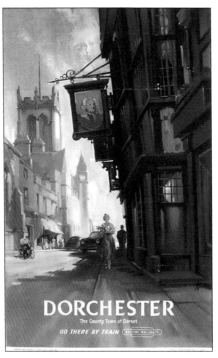

Dorchester: BR, Claude Buckle, 1950s

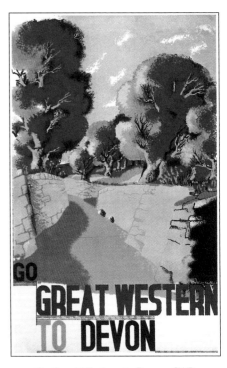

Go Great Western to Devon: GWR, Edward McKnight Kauffer, 1933

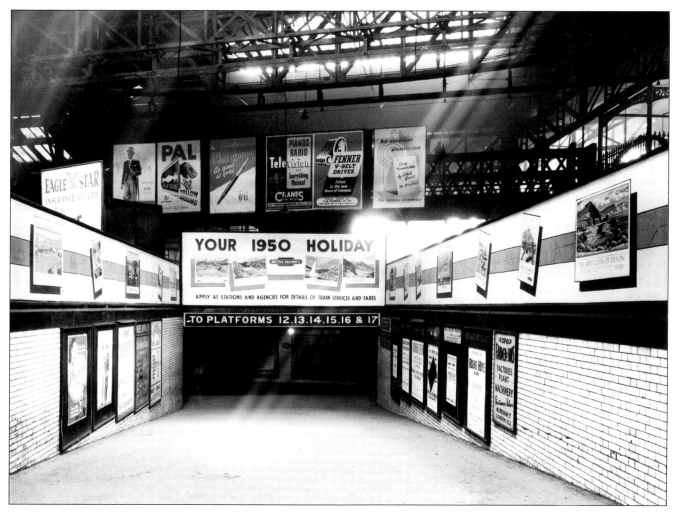

A display of holiday posters at Manchester Victoria station in 1950, including examples promoting Devon, Torquay, Penzance and Guernsey

DORSET COUNTY MUSEUM

Dorset's award-winning County Museum is located in High Street West in Dorchester, England. Founded in 1846, the museum covers the county of Dorset's history and environment. The current building was built in 1881 on the former site of the George Inn. The building, constructed in the Gothic Style, was designed specifically to house the museum's unique collections.

The museum includes over 2 million artefacts associated with archaeology (e.g. Maiden Castle), geology (e.g. the Jurassic Coast), history, art, famous local writers (e.g. Thomas Hardy) and natural science. There are video displays, activity carts for children, and an audio guide. The collections include fossilised dinosaur footprints, Roman mosaics and original Thomas Hardy manuscripts.

www.dorsetcountymuseum.org

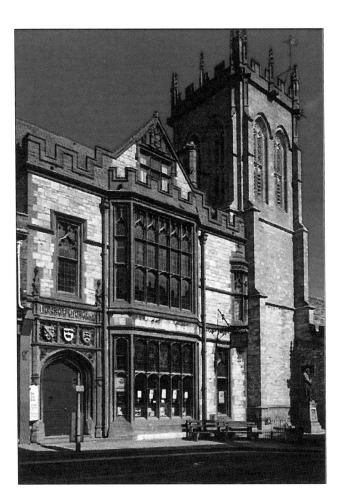
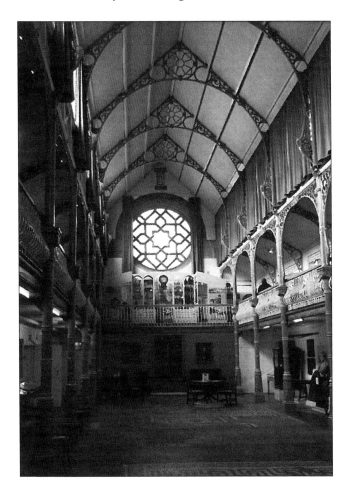